CARRY THIS BOOK

"Abbi is a visionary. She is fiercely creative, and her voracious imagination is palpable on these pages. Her illustration is a world I want to literally jump into and live in, and I'm closer to it than ever before with *Carry This Book*. It's interactive and voyeuristic, and the most delicious part is seeing inside Abbi's curious, romantic mind."

—ILANA GLAZER

"We've been asked what's in our wallets. We've been told what's in a name. Now Abbi looks at what's in the bags and suitcases of real and fictional people. Homer Simpson? Check. Michael Jordan? Check. Anna Wintour? Check. Looking at these illustrations and trying to guess who they belong to is like an inside-out game of *Where's Waldo?* You know what's amazing? After I was done reading, I emptied out my own Kipling bag, and this book was in it."

—QUESTLOVE

"Abbi is very smart. And she can write. And she can draw. She conquers all. Abbisolutely."

—MAIRA KALMAN

"Using a comedic, ingenious blurring of reality and fantasy, Abbi has created a wondrous peek into secret worlds. Her work captures something essential about her subjects, allowing us to revel and delight in an imagined space. *Carry This Book* is visually enchanting and a joy to read."

—CARRIE BROWNSTEIN

"The hilarious and lovely Abbi Jacobson is in book form. Fantastic!"

—AZIZ ANSARI

CARRY THIS BOOK

ABBI JACOBSON

VIKING

VIKING

An imprint of Penguin Random House LLC
375 Hudson Street
New York, New York 10014
penguin.com

ISBN 9780735221598

Printed in the United States of America
1 3 5 7 9 10 8 6 4 2

Set in Gotham
Designed by Abbi Jacobson

INTRODUCTION

Hi.

I wonder how this book made its way into your hands. You might have bought it because you are into *Broad City*, or someone gave it to you as a gift (solid friend), or maybe you're sitting in a dope waiting room full of cool books. However you stumbled upon it, you're here and I'm glad. So . . . What the fuck is this book? Is it a coffee-table book? I think so . . . I always wanted to make a book people would display on their coffee tables. You might be at some interesting, attractive person's house and THIS IS ON THEIR COFFEE TABLE!? Probably. Obviously. That's gotta be a high percentage of you.

So, welcome to my book. Let me give you a bit of an introduction to what you're about to get into:

I have always been intrigued by what people carry around with them. It can tell you everything. I like how people organize their things, their wallets, their cars, their bags, etc. We are curating our worlds almost constantly with the items we choose to bring with us.

How many tiny choices do you make every single morning before you leave

for work? SO MANY. Are you going out after? Is it going to rain? Are you running any errands—do you have any coupons or cards for specific stores you need to bring? Do you have to mail anything? Is there a big presentation today? Do you have to get fancier at some point during the day—put on makeup or change shoes? Hot date—is sex a possibility? When you add up all these little questions and all their little answers, you get to the stuff that separates one day from the next. The way we approach and react to all these questions is what interests me. I wonder what you carry around with you.

So, what is this book?

Every page is someone's stuff: I made a list of famous people and fictional characters and imagined what they might carry around with them. This book is my own sort of fan fiction—full of objects I think make people refreshingly interesting or refreshingly normal. We all have a lot more in common than we might know, and to think some of the world's greatest makers and shakers also have to remind themselves to buy more toilet paper is something I find worth noting.

Why these people?

The people included in this book were chosen for a variety of reasons. When I first pitched this idea, I wanted to explore my fascination with the fact that by simply seeing someone's belongings, you could gather so much information about them. I wanted to pick people that you would know in some way, people who have a historical influence on our culture—involved in politics, a prolific writer or musician, a known celebrity. I wanted to include famous fictional characters as well, as I thought it would be fun to explore what I knew about them while breaking the mold a bit.

I did some basic research and some deep Internet dives and chose facts I wanted to comment on in some way. I didn't include everything, and obviously all these people are more multidimensional than these illustrations. These are just a slice of them, and what I wanted to highlight, to poke fun at, to expose. Some of it might not make total sense, but it might spark some curiosity.

For instance, Einstein hated to wear socks—he never wore them. So when

you see on his page that he carries a pair ("in case anyone gives him shit"), it might not make total sense to you at first. But now it will and this was a HUGE SPOILER ALERT by the way.

My callouts throughout the book are from me directly to you. You'll see. You'll get it.

So I say, let this book wash over you like a spring breeze. Open yourself up to looking through people's fake bags and be a voyeur into my colorful land of fake shit. The world is a scary fucking place and maybe this will take your mind off something terrible for a little while. Honestly, if that's the case then I've done my job.

Hi.
WELCOME
INSIDE MY
WEIRDLY SPECIFIC,
AND ALSO
WILDLY RANDOM,
BOOK.

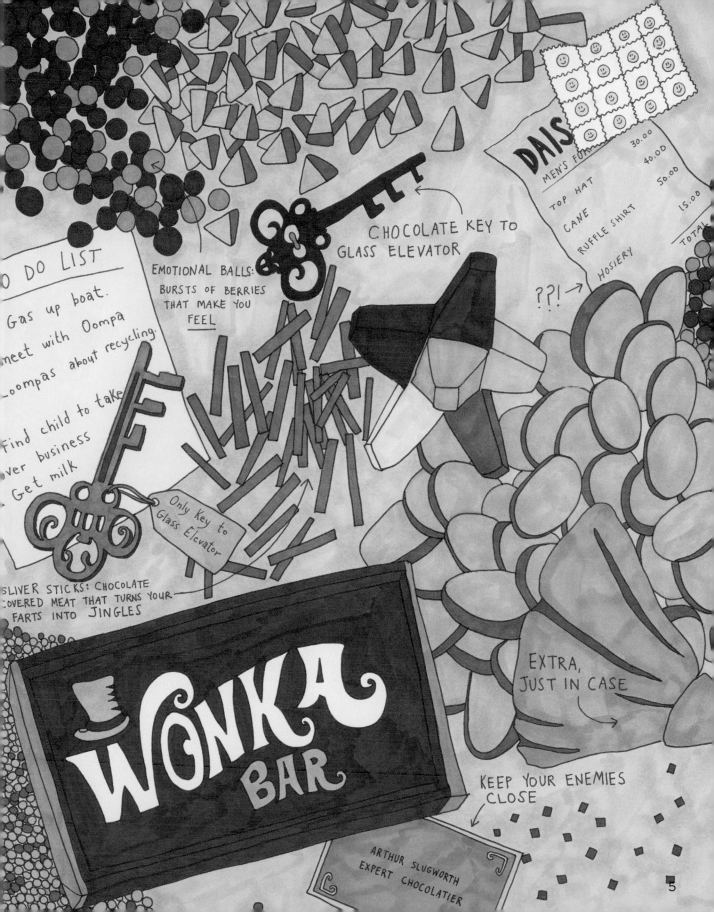

TO DO LIST

Gas up boat.
meet with Oompa
Loompas about recycling.

Find child to take
over business
Get milk

EMOTIONAL BALLS:
BURSTS OF BERRIES
THAT MAKE YOU
FEEL

CHOCOLATE KEY TO
GLASS ELEVATOR

Only Key to
Glass Elevator

SLIVER STICKS: CHOCOLATE
COVERED MEAT THAT TURNS YOUR
FARTS INTO JINGLES

DAIS

MEN'S FO...

TOP HAT	30.00
CANE	40.00
RUFFLE SHIRT	50.00
HOSIERY	15.00
TOTAL	

??!

EXTRA,
JUST IN CASE

WONKA BAR

KEEP YOUR ENEMIES
CLOSE

ARTHUR SLUGWORTH
EXPERT CHOCOLATIER

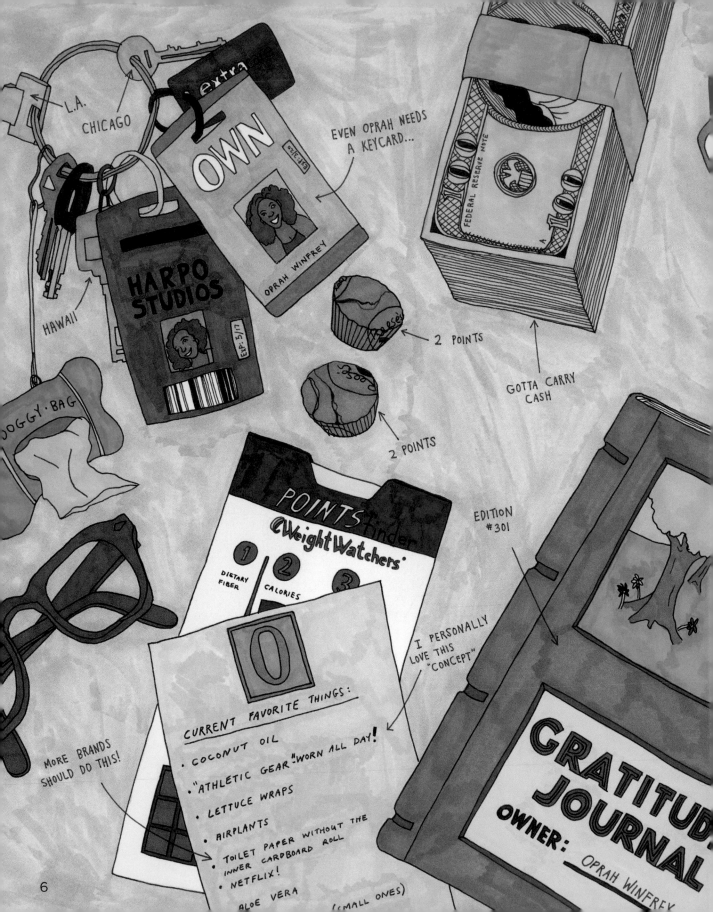

L.A.

CHICAGO

HAWAII

HARPO STUDIOS

OWN

OPRAH WINFREY

EXP: 5/17

EVEN OPRAH NEEDS A KEYCARD...

FEDERAL RESERVE NOTE

GOTTA CARRY CASH

2 POINTS

2 POINTS

DOGGY·BAG

EDITION #301

POINTS finder
WeightWatchers

1 DIETARY FIBER 2 CALORIES 3

I PERSONALLY LOVE THIS "CONCEPT"

MORE BRANDS SHOULD DO THIS!

0

CURRENT FAVORITE THINGS:

• COCONUT OIL

• "ATHLETIC GEAR" WORN ALL DAY!

• LETTUCE WRAPS

• AIRPLANTS

• TOILET PAPER WITHOUT THE INNER CARDBOARD ROLL

• NETFLIX!

ALOE VERA (SMALL ONES)

GRATITUDE JOURNAL

OWNER: OPRAH WINFREY

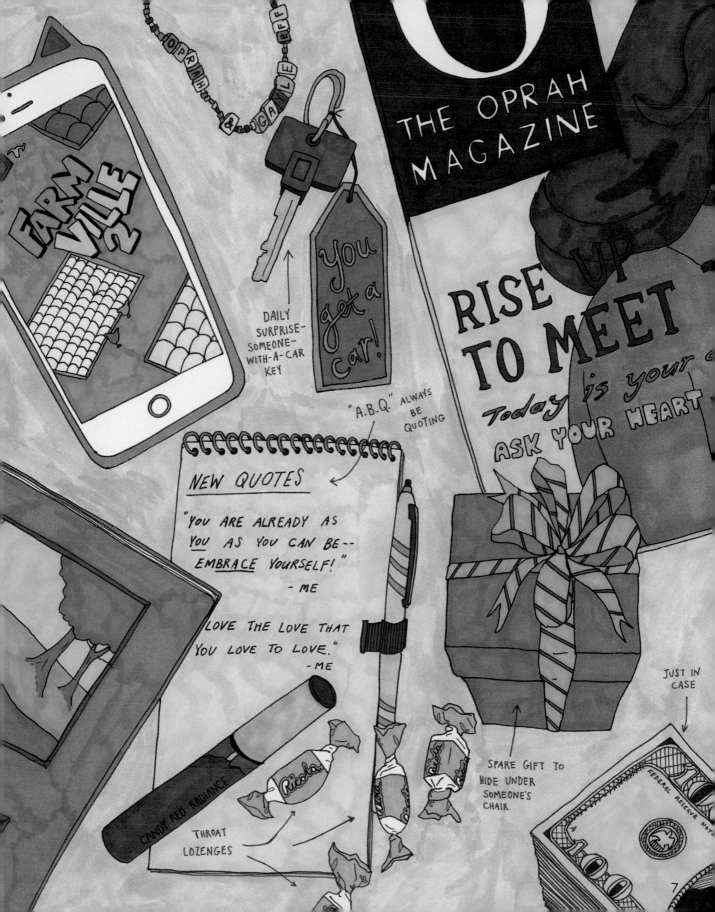

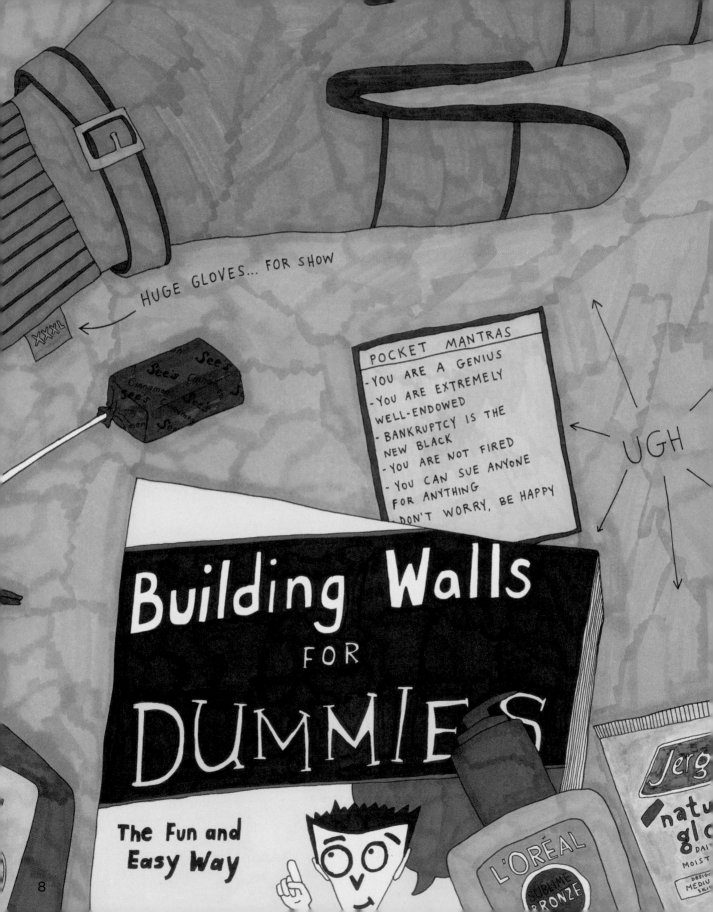

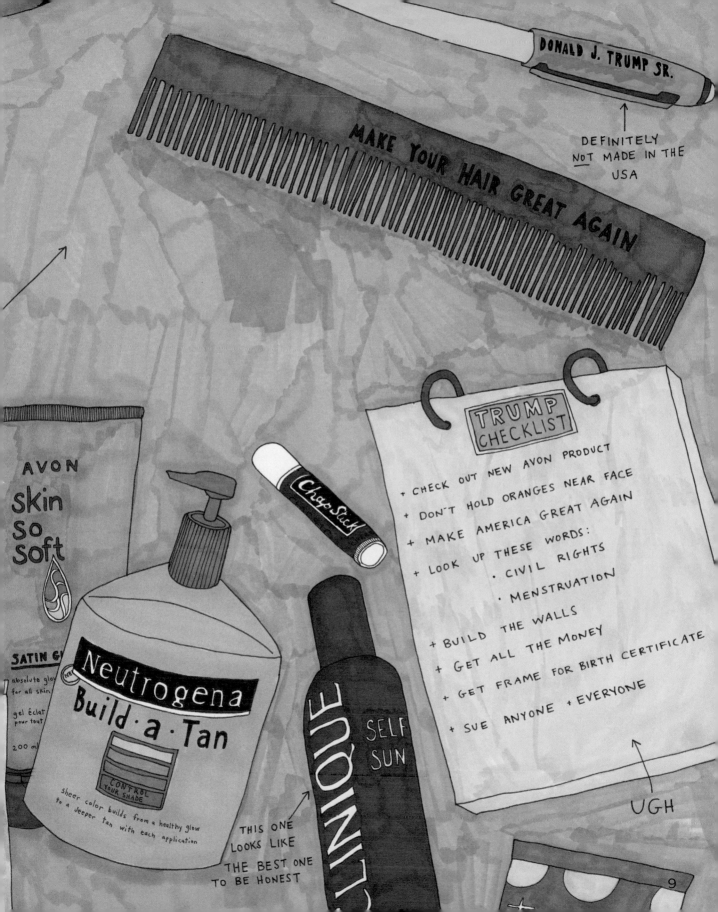

THE SENTENCE OF THE COURT OF THE UNITED STATES

NEVER PAID A CENT OF THIS BULLSHIT

AGAINST SUSAN B. ANTHONY ON THE CHARGE OF ILLEGALLY

VOTING IS THAT SHE WILL PAY THE COURT

$100 AND COSTS OF PROSECUTION.

ISSUED BY JUDGE HUNT

THURSDAY

* 7:30 pm Dinner with Elizabeth Cady St

RIDAY *MERGE ASSOCIATIONS

slavery society meeting

DAY/SUNDAY

11

WHAT TO CARRY:
TIP #1

WHEN GOING ON A TRIP, ALWAYS BRING A PLASTIC BAG FOR DIRTY CLOTHES.

(UNDERWEAR)

APT.

SMALLER TELESCOPE ROOM

HAYDEN PLANETARIUM

HUGE TELESCOPE ROOM

StarTalk
KEYCARD
NEIL DEGRASSE TYSON

FAVORITE PARTS

COSMOS
CARL SAGAN

WINE CLUB
MEETING
SATURDAYS
1:30 PM

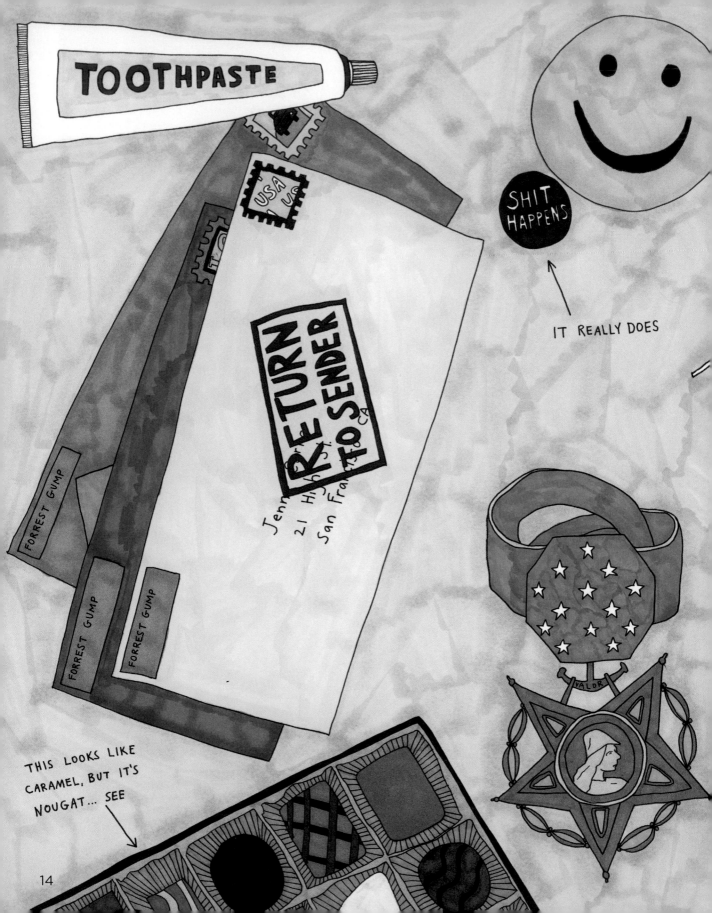

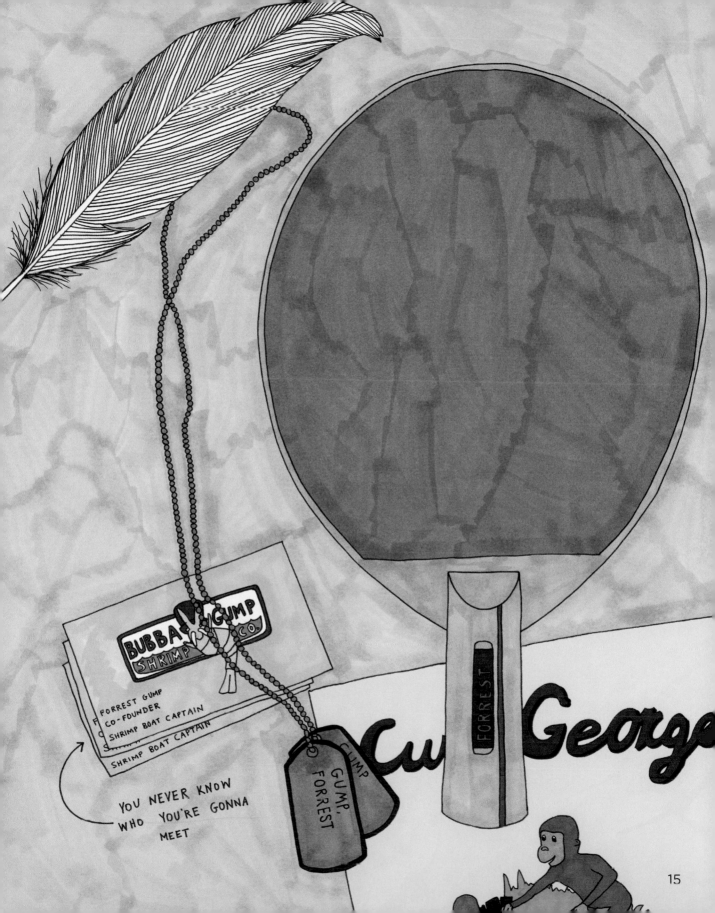

BUBBA GUMP SHRIMP CO.

FORREST GUMP
CO-FOUNDER
SHRIMP BOAT CAPTAIN
SHRIMP BOAT CAPTAIN

YOU NEVER KNOW WHO YOU'RE GONNA MEET

GUMP, FORREST

FORREST

Cu George

15

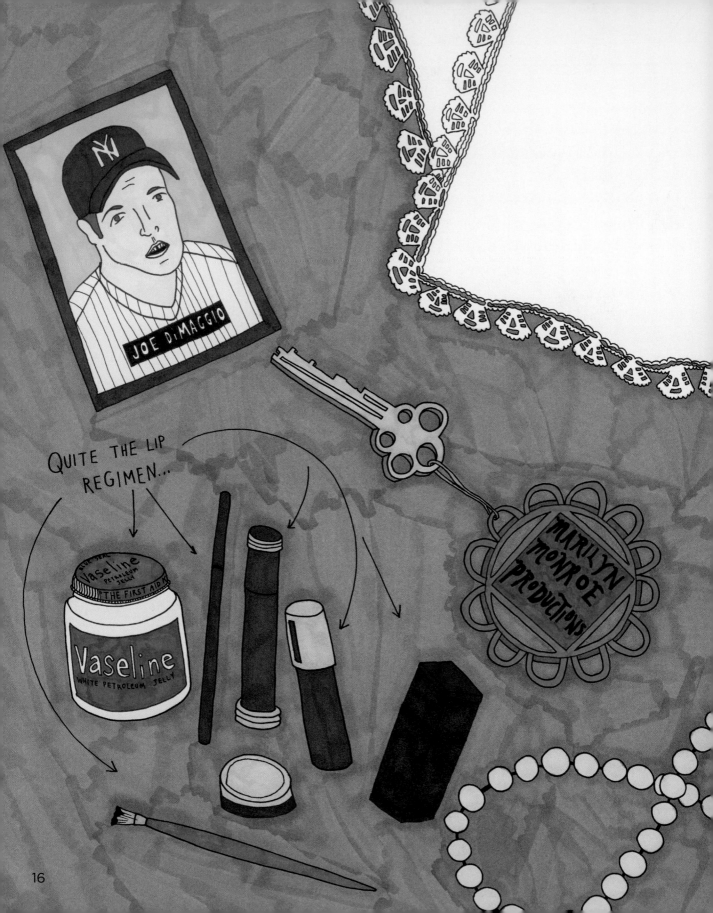

JOE DiMAGGIO

QUITE THE LIP
REGIMEN...

Vaseline
WHITE PETROLEUM JELLY

MARILYN
MONROE
PRODUCTIONS

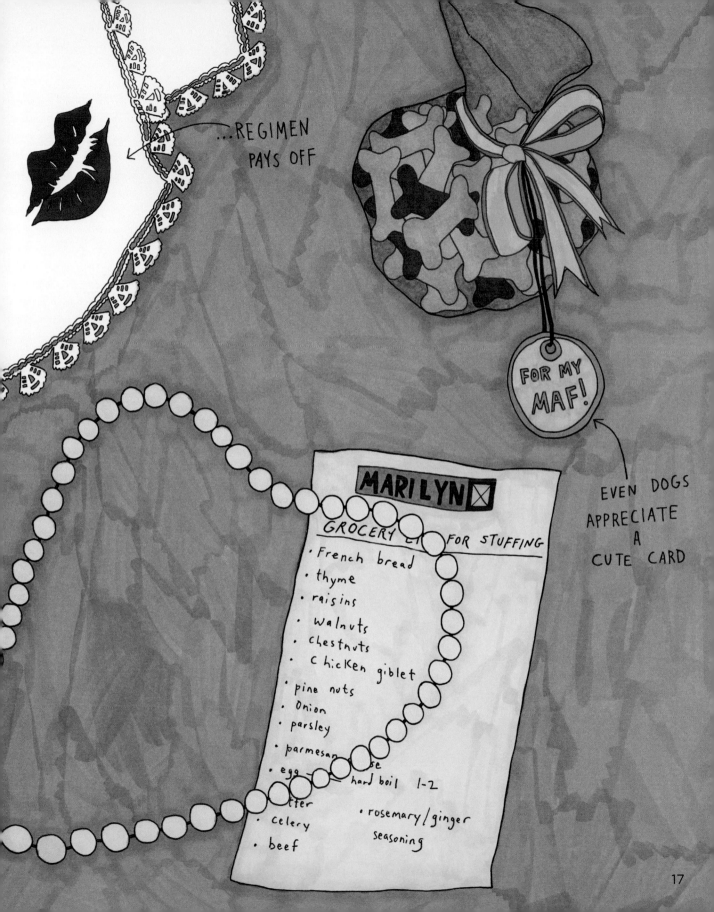

...REGIMEN PAYS OFF

FOR MY MAF!

EVEN DOGS APPRECIATE A CUTE CARD

MARILYN ☒

GROCERY LIST FOR STUFFING

• French bread
• thyme
• raisins
• walnuts
• chestnuts
• chicken giblet
• pine nuts
• onion
• parsley
• parmesan ... se
• egg ___ hard boil 1-2
• ___ tter
• celery • rosemary/ginger
• beef seasoning

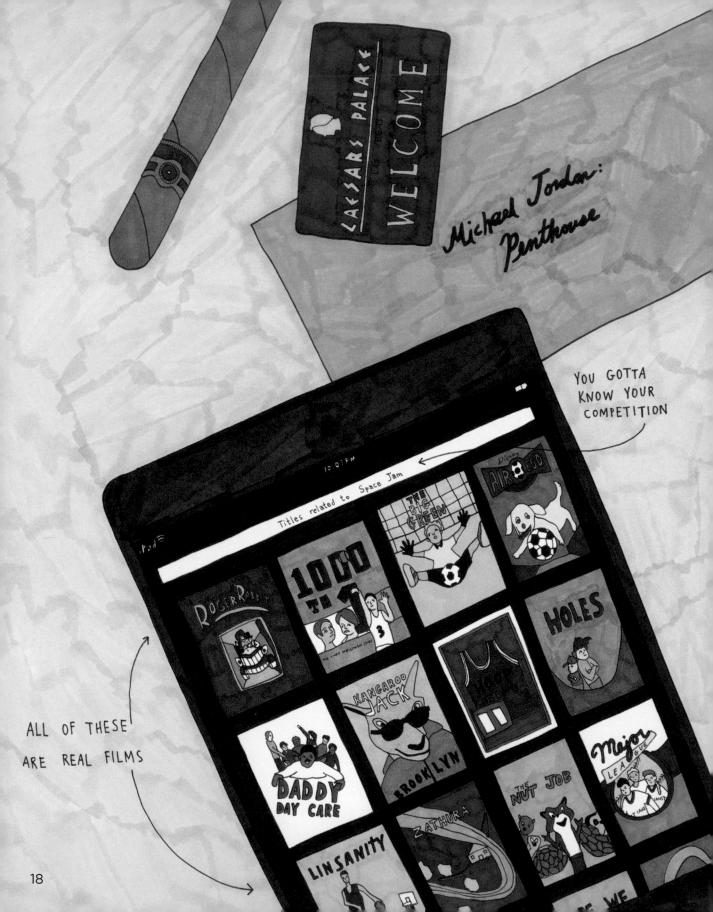

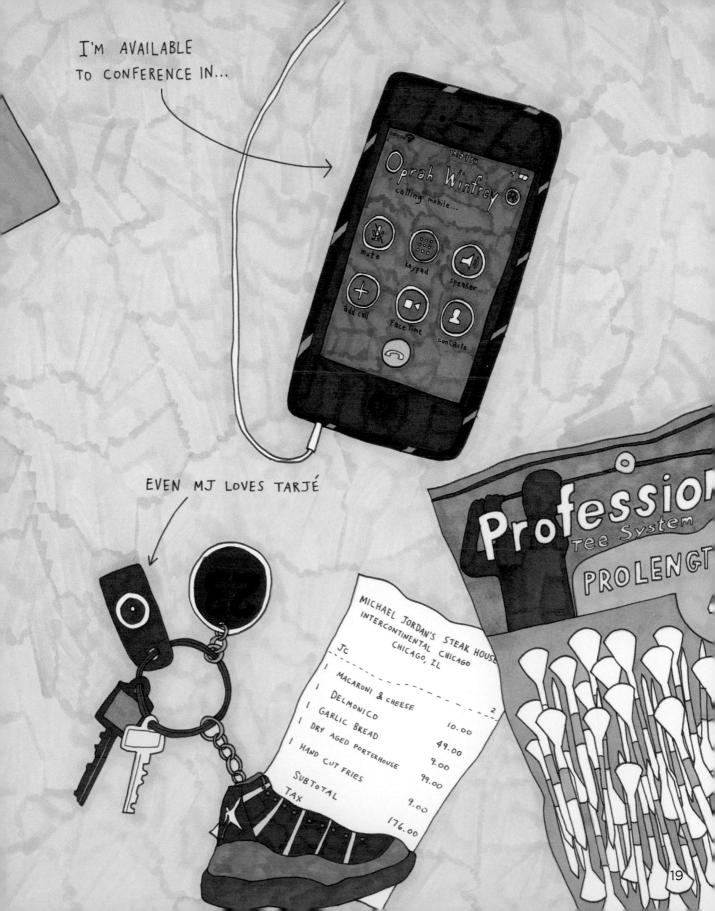

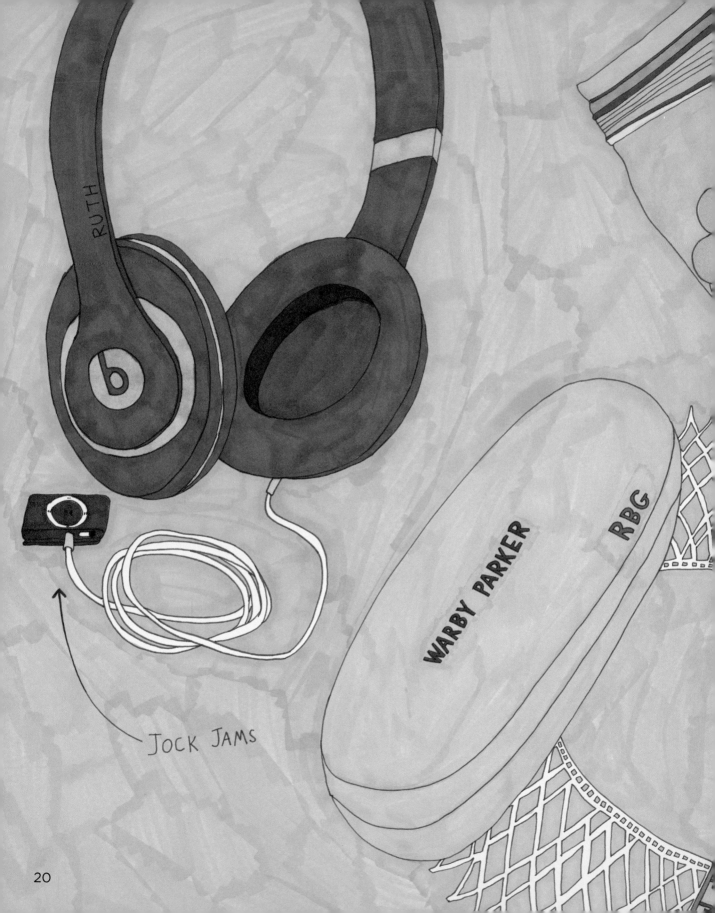

RUTH

JOCK JAMS

WARBY PARKER

RBG

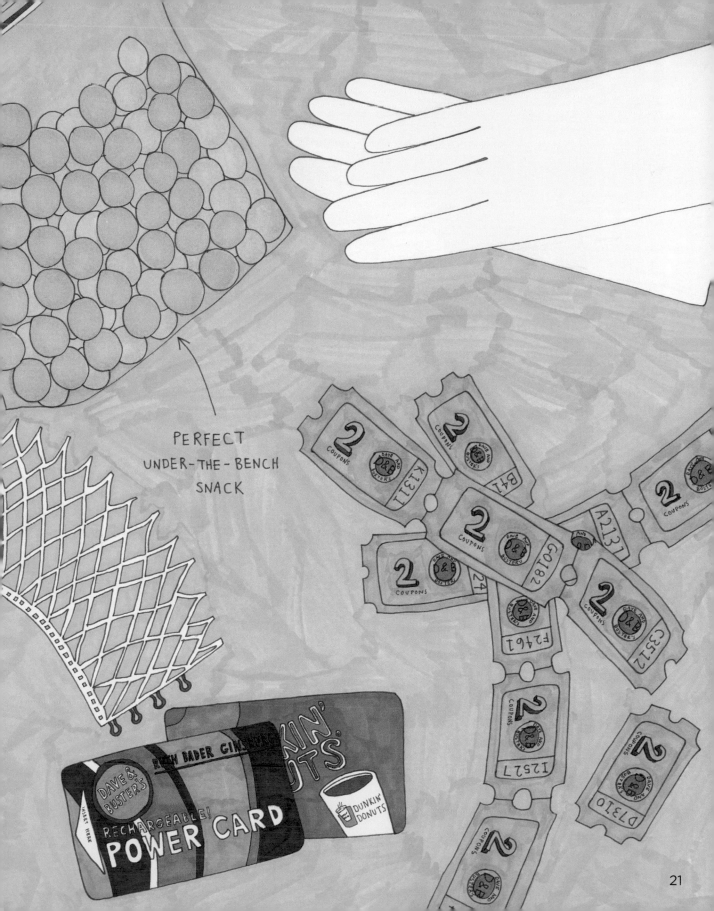

PERFECT
UNDER-THE-BENCH
SNACK

21

YOU
ARE
WHAT
YOU
CARRY

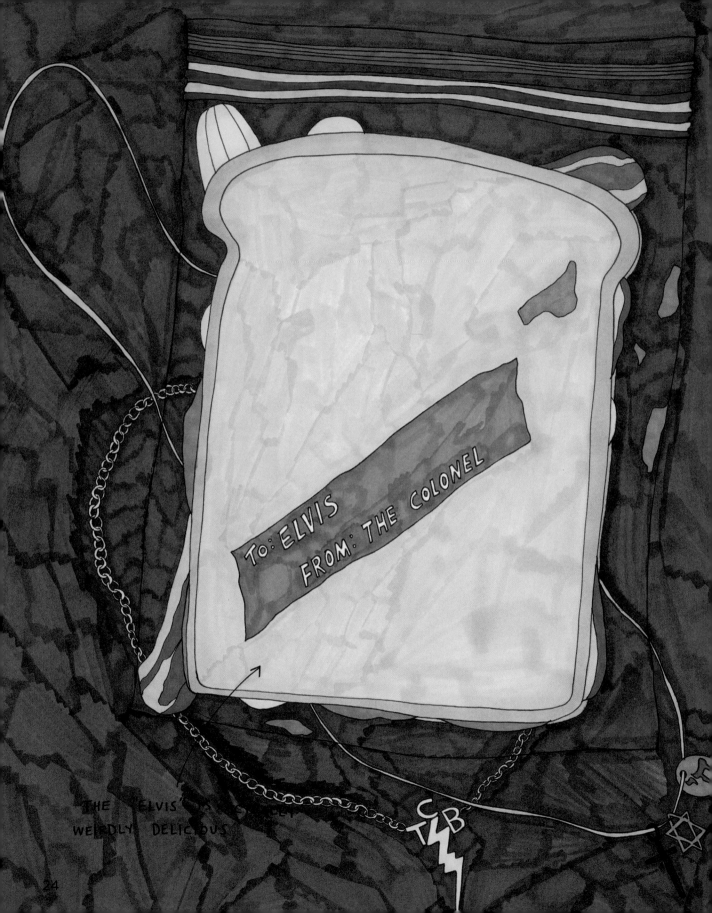

THE "ELVIS" SANDWICH:
WEIRDLY DELICIOUS

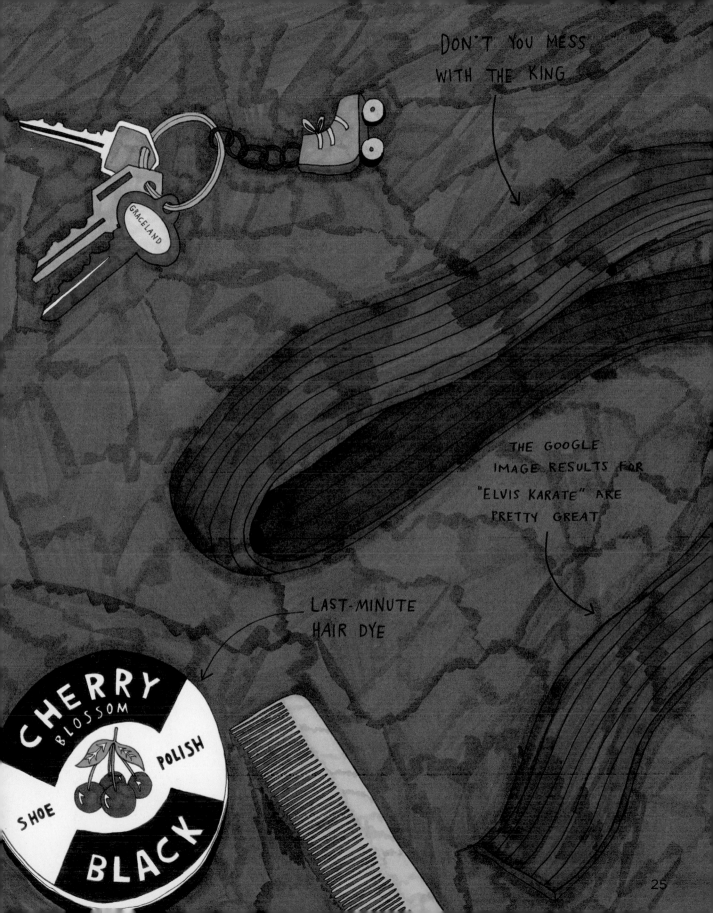

DON'T YOU MESS WITH THE KING

GRACELAND

THE GOOGLE IMAGE RESULTS FOR "ELVIS KARATE" ARE PRETTY GREAT

LAST-MINUTE HAIR DYE

CHERRY BLOSSOM SHOE POLISH BLACK

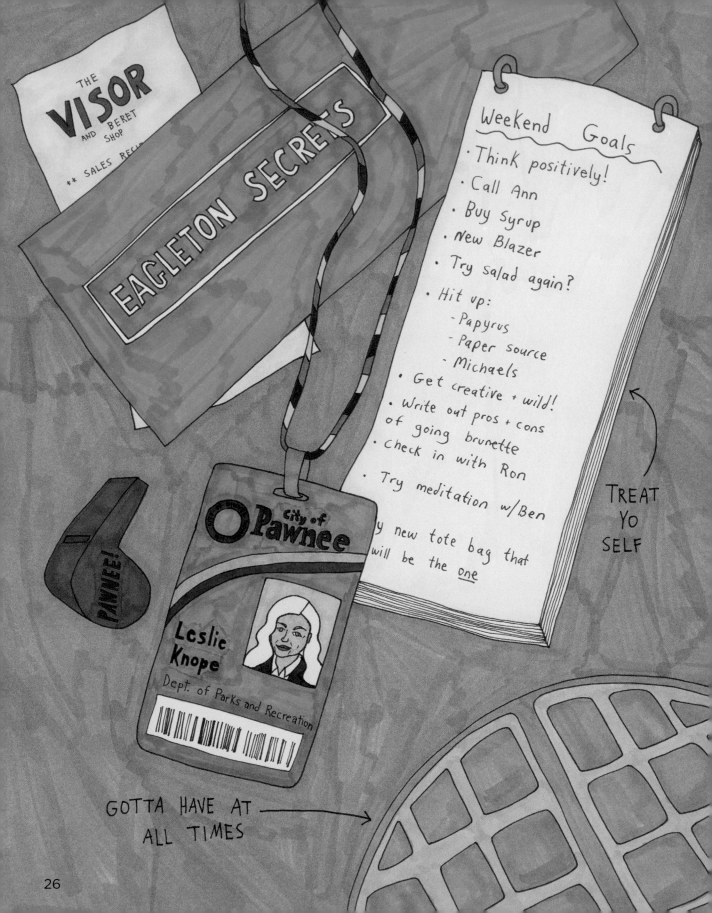

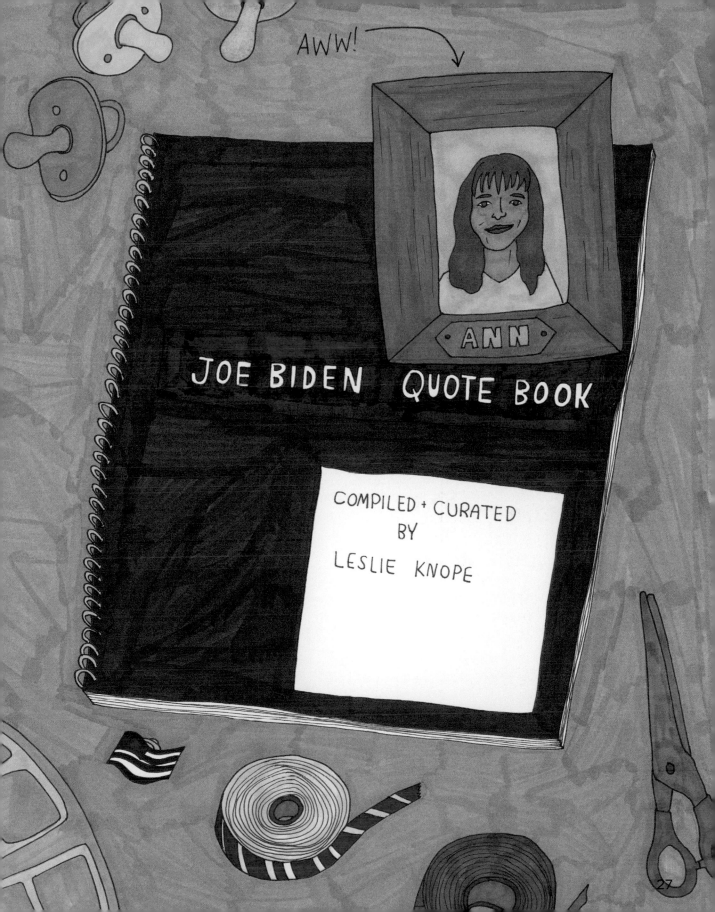

THE CONTENTS OF MY TRAVEL TOILETRY BAG:

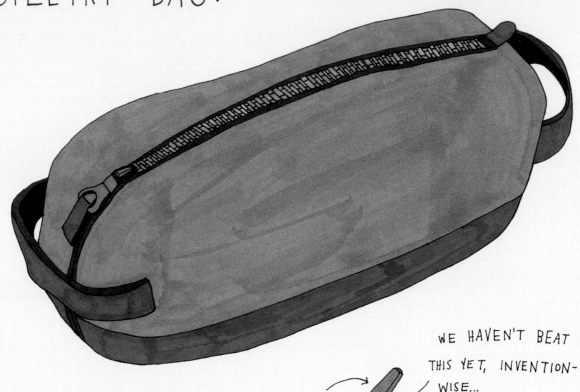

- TOOTHBRUSH ← IN PLASTIC TRAVEL CASE

WE HAVEN'T BEAT THIS YET, INVENTION-WISE...

- MINI TOOTHPASTE
- FLOSS
- SHOWER CAP
- NAIL CLIPPERS
- TWEEZERS
- A COMB

PONYTAILS!

- 4 VARIOUS HAIR TIES
- 7 ROGUE BOBBY PINS
- 1 HAIR CLIP FOR BIGGER PROJECTS
- NAIL FILE
- 2 NAIL POLISH REMOVER PADS

- DRY SHAMPOO ← I WAS REALLY LATE TO THIS PRODUCT, + NOW... I NEED IT.

- SULFATE-FREE SHAMPOO ← KERATIN HAIR TREATMENT

- SEA SALT SPRAY

- TAMPONS ← VARIOUS SIZES, OBVIOUSLY

- 4 PANTY LINERS

- 4 LEGIT PADS ← IN CASE + FOR PEACE OF MIND

- MIDOL

- ADVIL

- MAKEUP REMOVER TOWELETTES

- A RAZOR

- BLADE REFILLS

- HOTEL MOISTURIZER ← CAN'T STOP TAKING THESE

- 6 DIFFERENT TINY EYE CREAMS

3 AESOP SAMPLES

KIEHL'S TEENY BOTTLE

TEENSY LA MER SAMPLE FROM 2 YEARS AGO

SMALLEST MURAD POSSIBLE

- BROW PENCIL ← HAVE TO BE CAREFUL WITH THIS

- MASCARA

- BROW GEL ← HOLD IT TIGHT

- EYE SHADOW ← DARK PURPLE
 - EYE SHADOW BRUSH

- BLUSH

- LIP GLOSS

- LIPSTICK ← NUDE + RED ← THIS IS A WHOLE LITTLE PROCESS

- TINY PERFUME SAMPLES

- FOAM EGG ← FOR BLENDING

- 2 CONDOMS

- "HYDRATING DEEP MOISTURE TISSUE FACIAL MASK"

* THIS IS COMPLETELY INSANE, RIGHT??

HOW DO I HAVE/NEED SO MANY THINGS? HOW HAVE I ACCUMULATED SO MANY "ESSENTIALS"?

WHEN DID I FIND THE TIME?

... I KNOW IT WILL ONLY GROW...

EXTRA GUAC, ALWAYS

ANNA WINTOUR'S
CUSTOM MADE, HAND-CRAFTED
RESPONSIBLY RAISED, SUSTAINABLY GROWN
BURRITO CARD

CHIPOTLE
MEXICAN GRILL

Anna Wintour
Vogue Magazine

ROGER FEDERER FAN CLUB

Fans4r
P
CH

SEND OUT
ON
MONDAY!

ANNA +
ROGER
SITTING IN
A TREE...

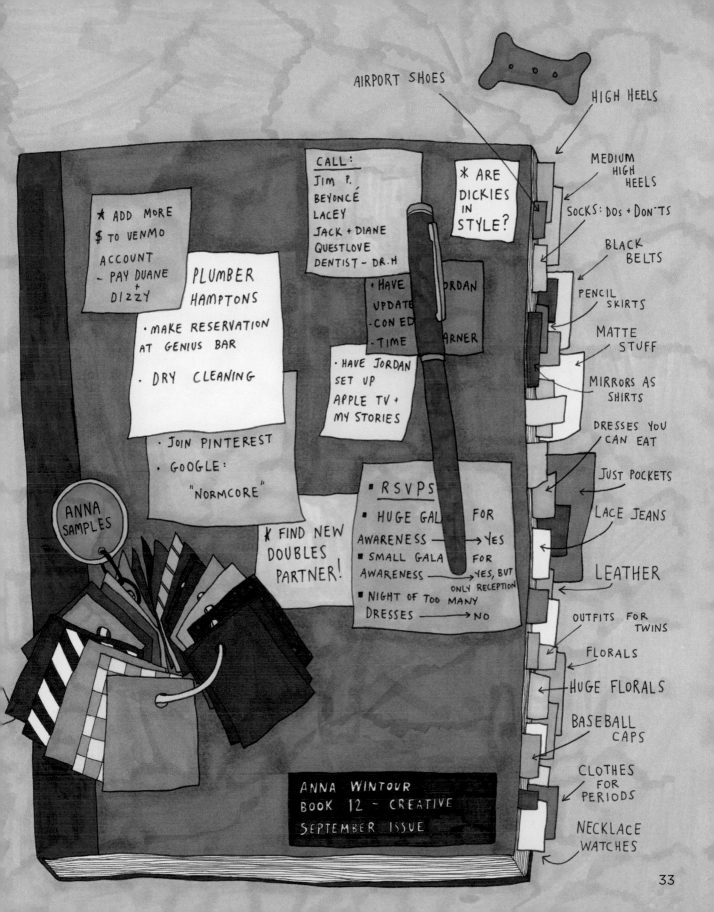

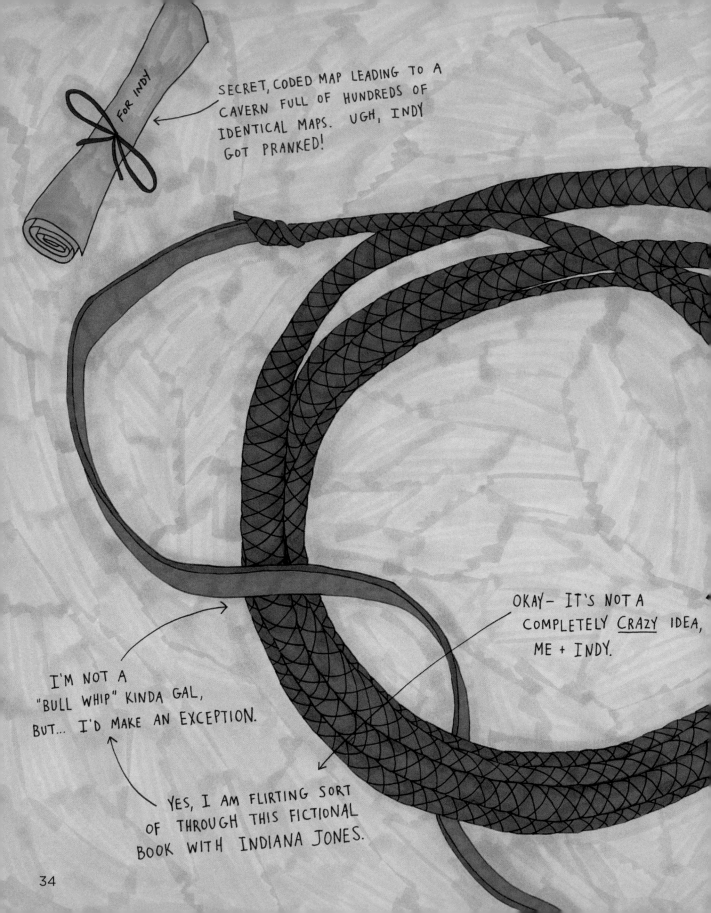

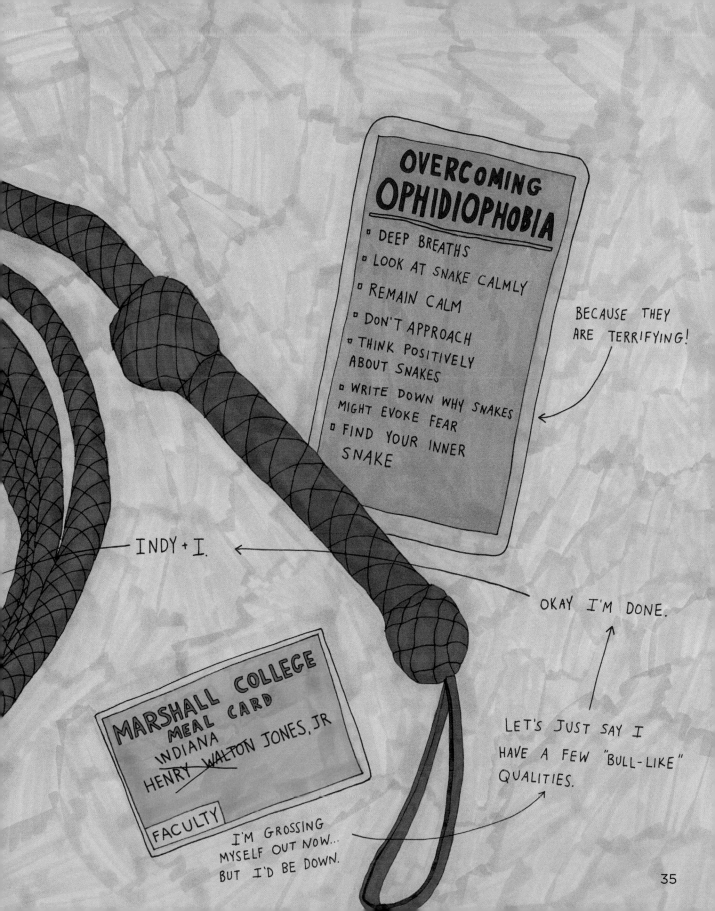

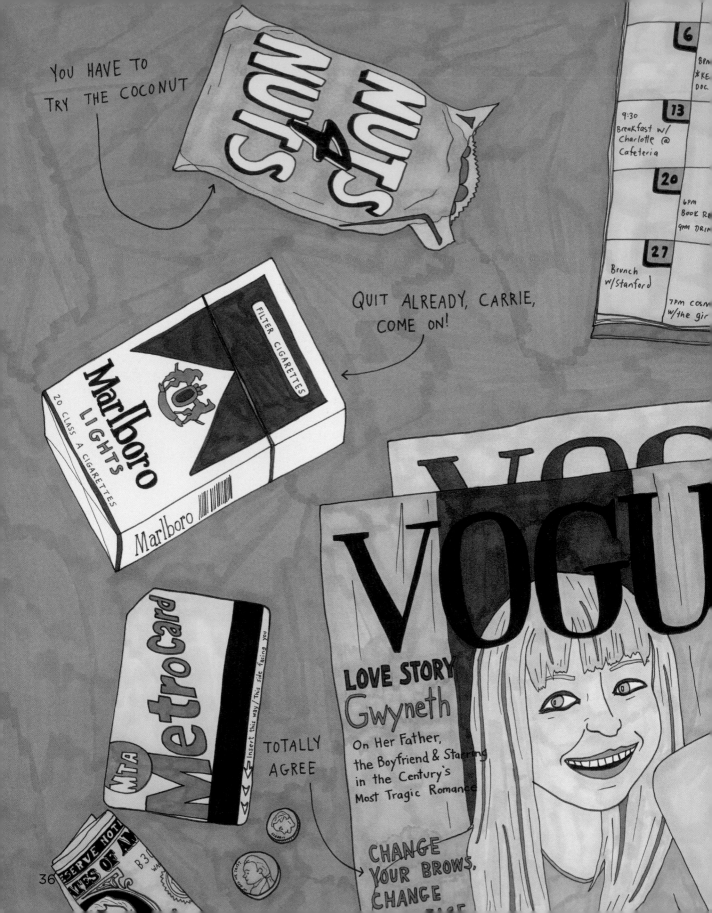

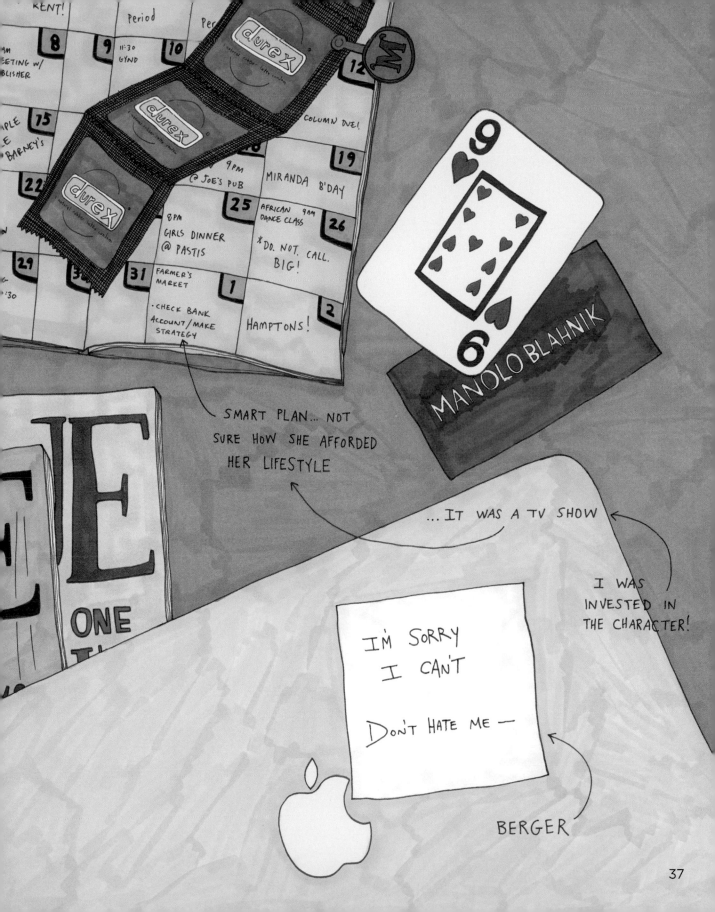

GOOD ALIENS.
WHY DO ALIENS ALWAYS HAVE
TO BE TERRIFYING? MAYBE THEY'RE
GREAT!

ALIENS MIGHT READ
THIS BOOK +
SPARE ME...

OTHER LIFE

US

39

EVERYONE ————

ANGER
LOVE
GOALS
DREAD
EMOTIONAL BAGGAGE
→ REGRETS
AMBITIONS
SORROWS
HOPES
ANXIETY
DREAMS
PAIN

41

A LITTLE FRENCH PORN NEVER HURT ANYONE... THIS IS A LONG FLIGHT

La Culture Physique

Le N° 2 f 50

OHH SHIT

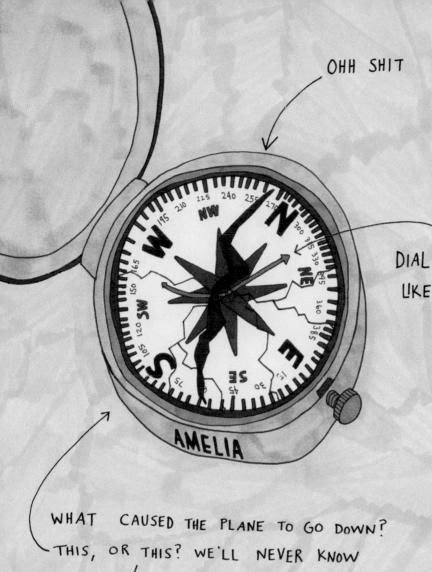

AMELIA

DIAL IS SPINNING
LIKE CRAZY!

WHAT CAUSED THE PLANE TO GO DOWN?
THIS, OR THIS? WE'LL NEVER KNOW

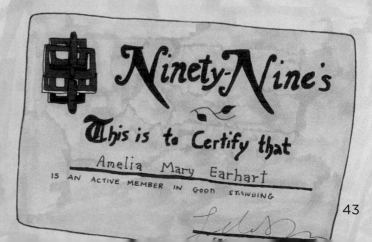

Ninety-Nine's
This is to Certify that
Amelia Mary Earhart
IS AN ACTIVE MEMBER IN GOOD STANDING

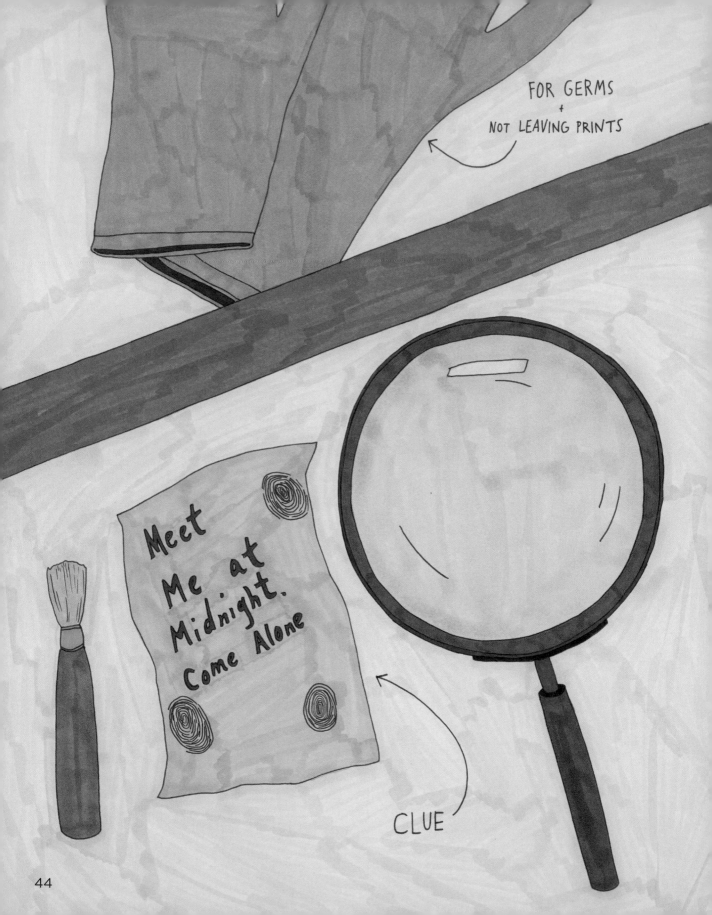

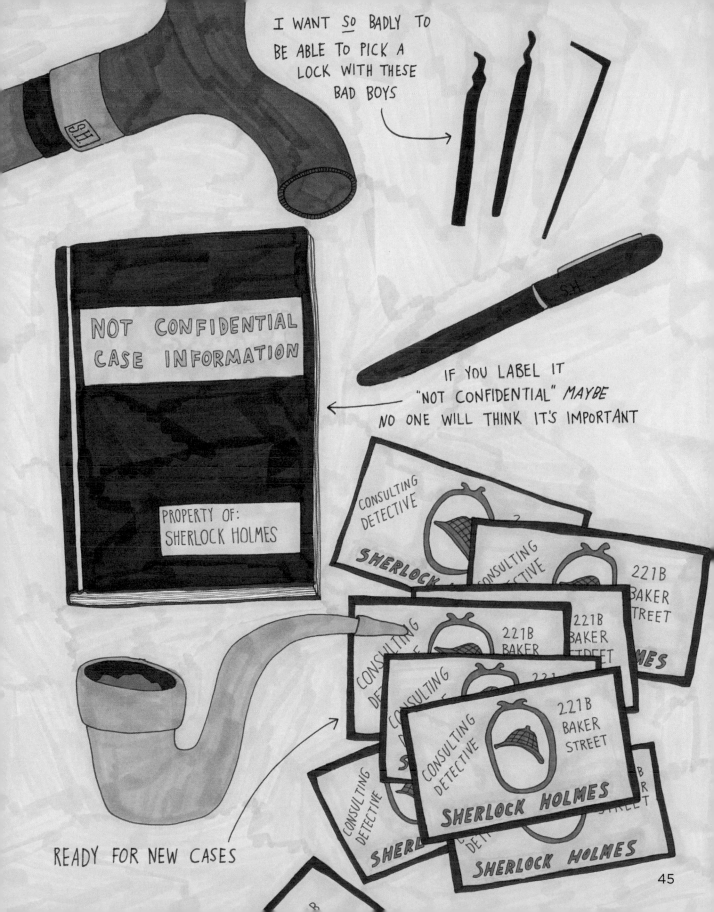

45

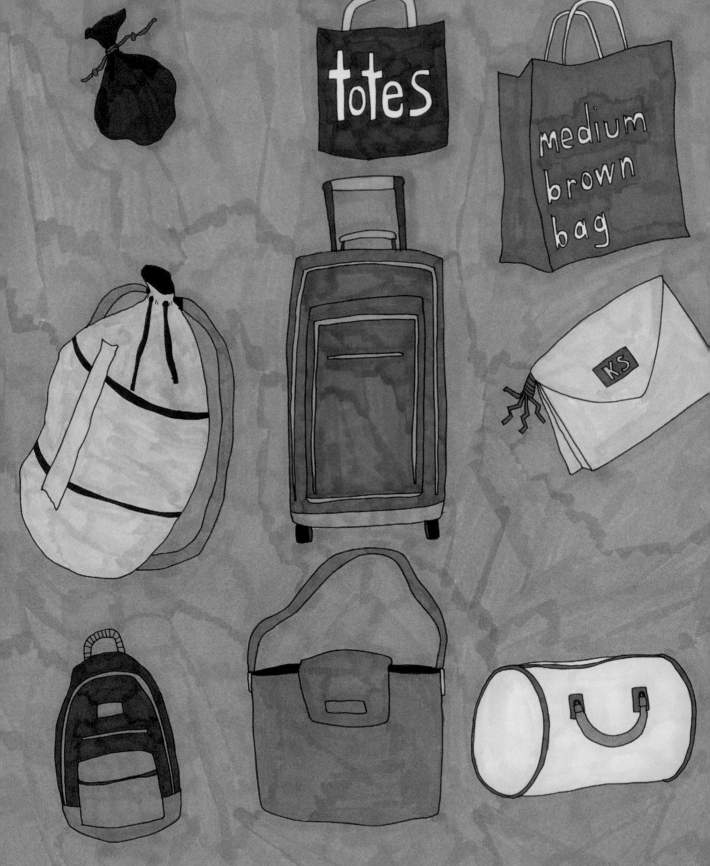

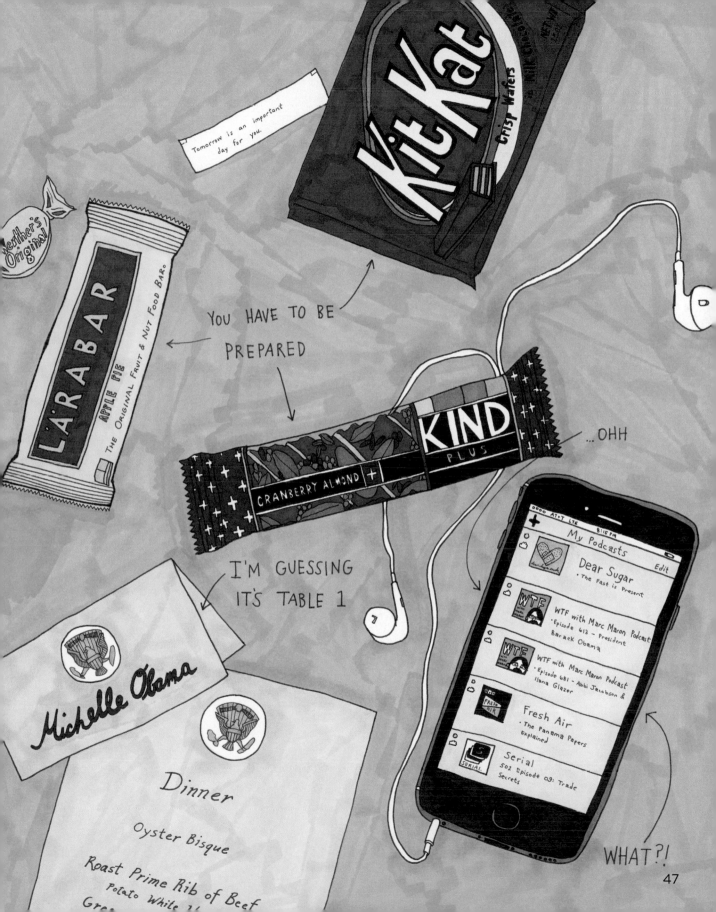

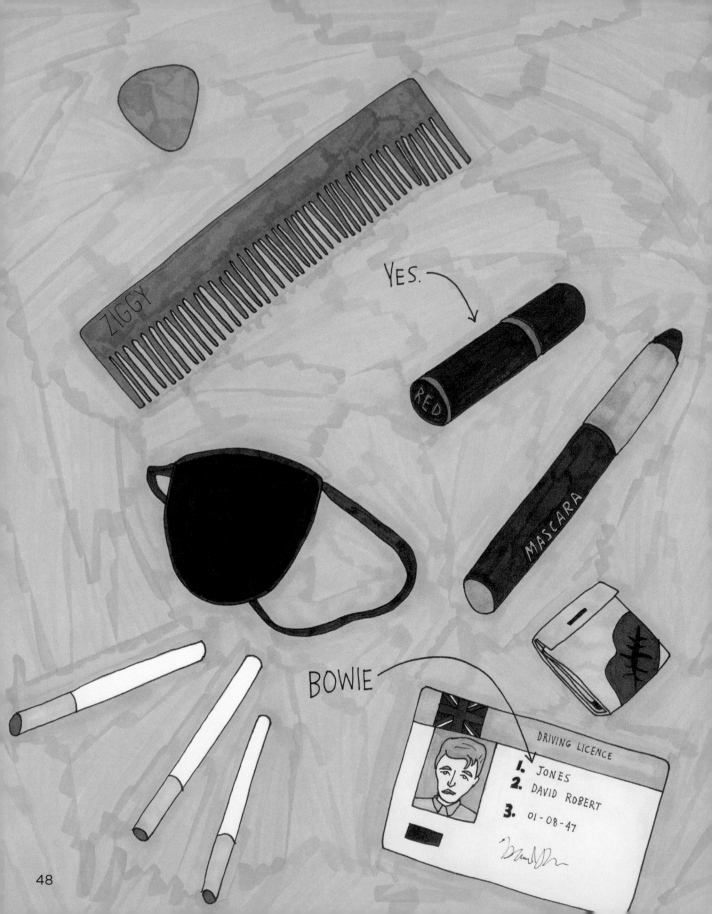

ALL VALID + ALL EXTRAORDINARY

DRIVING LICENCE
1. TOM
2. MAJOR

DRIVING LICENCE
2. IGGY
Ziggy Stardust

DRIVING LICENCE
1. SANE
2. ALADDIN

DRIVING LICENCE
1. DUKE
2. THE THIN WHITE

DRIVING LICENCE
1. JONES
2. TAO

DRIVING LICENCE
1. JACK
2. HALLOWEEN

1. MEA
2. JOHN

51

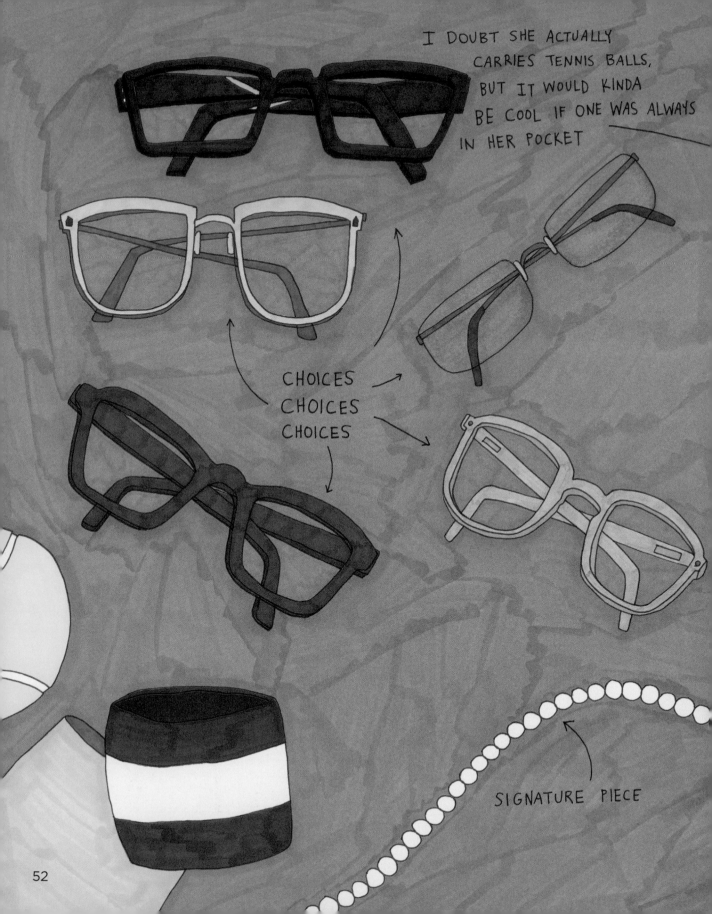

I DOUBT SHE ACTUALLY CARRIES TENNIS BALLS, BUT IT WOULD KINDA BE COOL IF ONE WAS ALWAYS IN HER POCKET

CHOICES
CHOICES
CHOICES

SIGNATURE PIECE

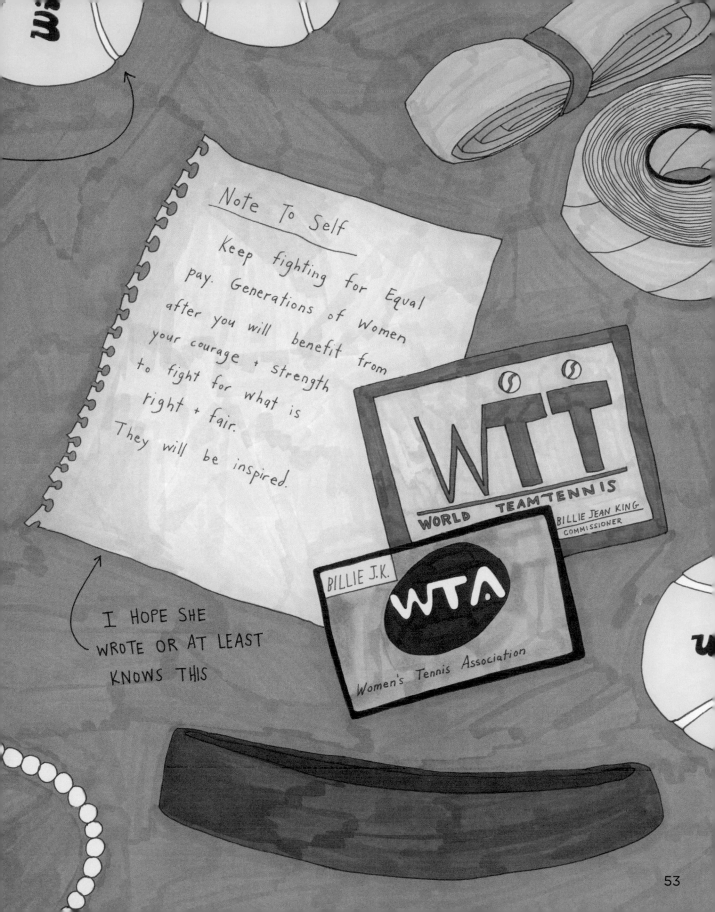

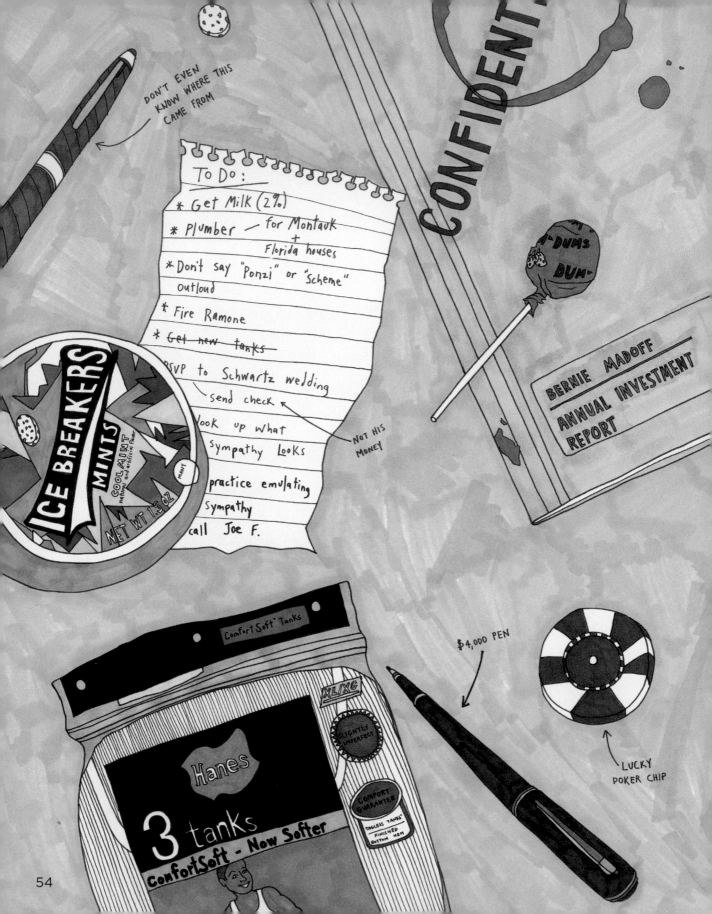

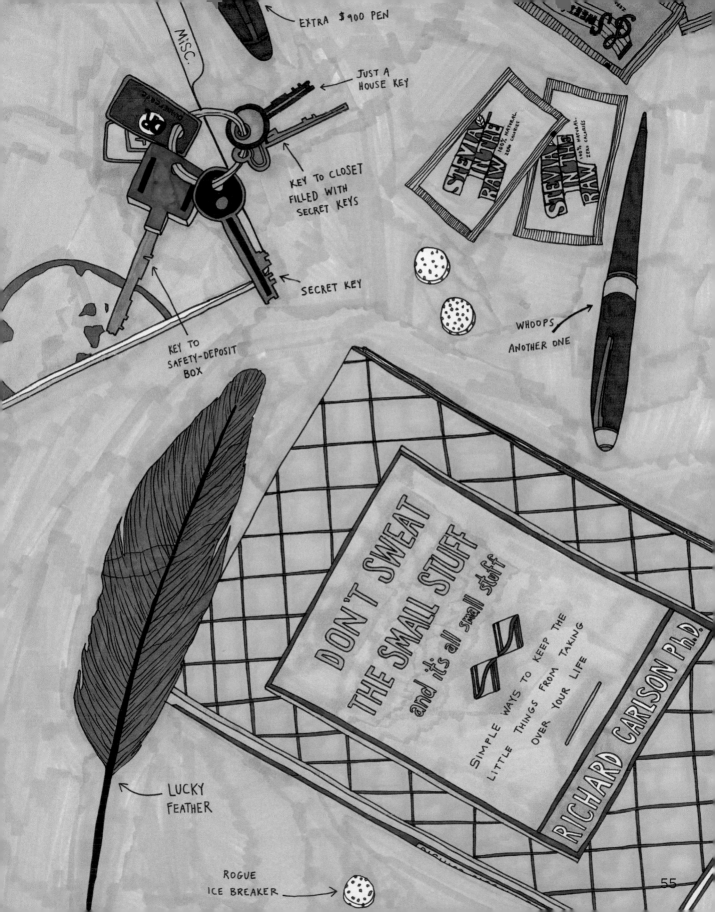

EXTRA $900 PEN

MiSC.

JUST A HOUSE KEY

KEY TO CLOSET FILLED WITH SECRET KEYS

SECRET KEY

KEY TO SAFETY-DEPOSIT BOX

STEVIA IN THE RAW 100% NATURAL· ZERO CALORIES

STEVIA IN THE RAW 100% NATURAL· ZERO CALORIES

WHOOPS ANOTHER ONE

DON'T SWEAT THE SMALL STUFF and it's all small stuff

SIMPLE WAYS TO KEEP THE LITTLE THINGS FROM TAKING OVER YOUR LIFE

RICHARD CARLSON Ph.D.

LUCKY FEATHER

ROGUE ICE BREAKER

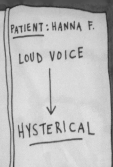

PATIENT: HANNA F.

LOUD VOICE

↓

HYSTERICAL

BONUS PACK

CLARK

TEABERRY

PERSONAL FIELD NOTES

- The week I had that nasty sty in my eye and made the patients lie on the chaise, looking away from me, led to more revelations and discoveries than ever before! Keep this going??

- Reread Oedipus Rex

- Smoking does make you look cooler!

- Maybe experiment with new look? Facial hair? Goatee?

- Less eye contact = breakthroughs!

SONGS
AND SONNETS
OF
WILLIAM
SHAKESPEARE

PATIENT: ANNA

HYSTERIA

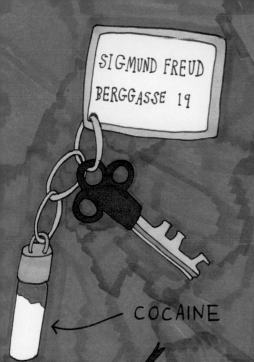

SIGMUND FREUD
BERGGASSE 19

COCAINE

TO DO

* BUY MARTHA FLOWERS... AND MINNA

* BUY MORE COCAINE → BULK

* MAP OUT HOUR OR SO THIS WEEKEND
AND FOCUS ON OWN "DEATH DRIVE" ——
WHY ARE YOU SO SELF-DESTRUCTIVE?

* FINALIZE PRANK ON JUNG

* WRISTWATCH VS. POCKET WATCH?
 └ WRITE PROS + CONS

* TOILET PAPER!

DON'T GET
ME STARTED

PATIENT: ERNST L.

Free association led
to deep discovery
of childhood trauma.

* TRY THE COUCH
THING NEXT WEEK!

PATIENT: FANNY P.

COUGH
↓
HYSTERIA

INTERESTING
PATTERN...

* KEEP THIS
NAPKIN!

id!
ego!
superego!

CAFE CENTRAL

57

POCKETS
SUITCASE
DUFFEL BAG
PURSE
FANNY PACK
HANDBAG
WALLET
CHANGE PURSE
TOTE BAG
SATCHEL
PENCIL CASE
MESSENGER BAG
BRIEFCASE
SHOPPING BAG
TOOLBOX
WEEKENDER
GLOVE COMPARTMENT
LUGGAGE
BOOKBAG
CLUTCH

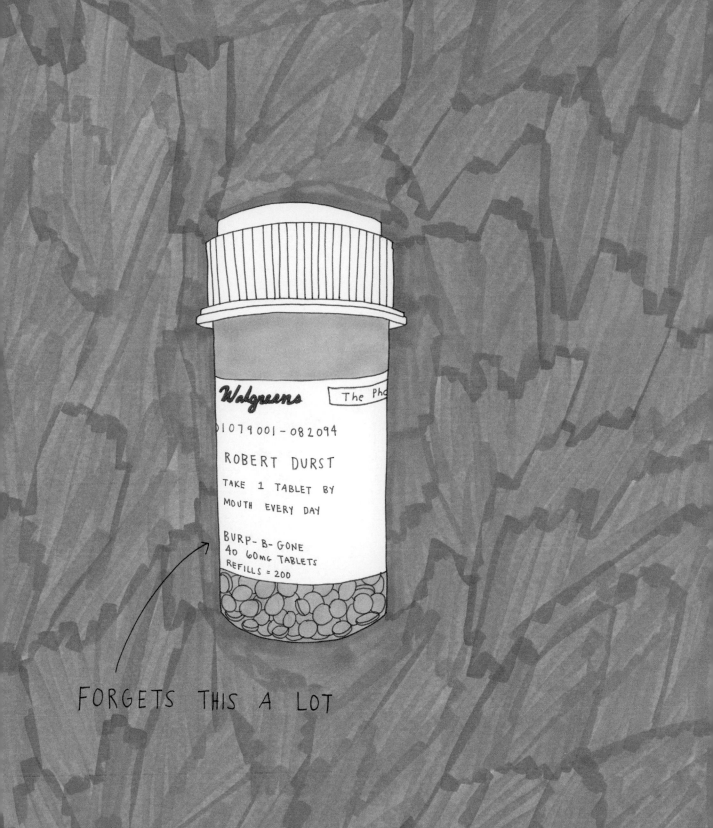

FORGETS THIS A LOT

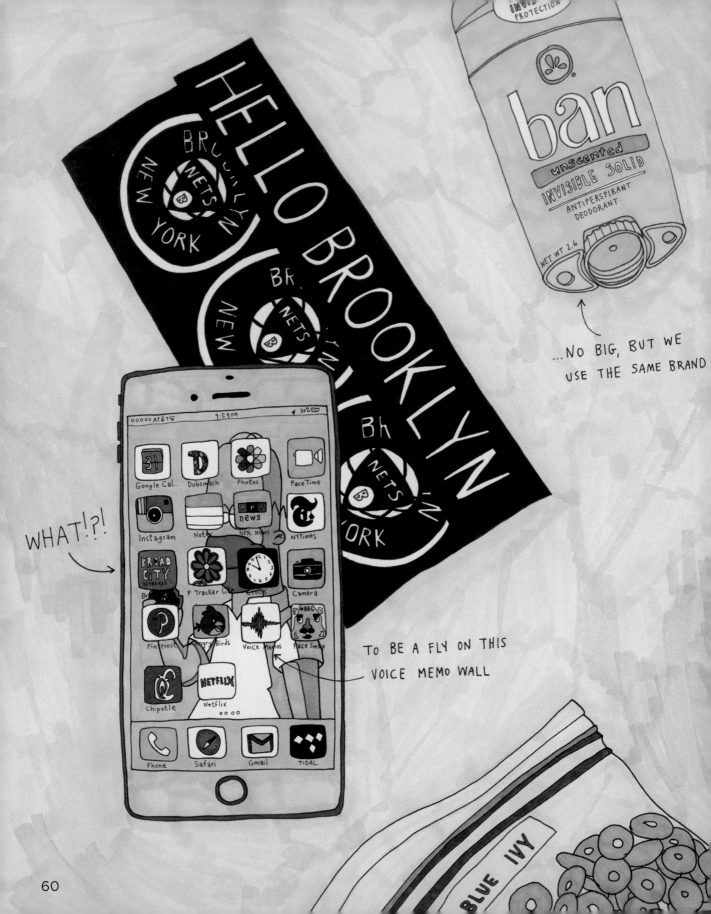

WHAT!?!

...NO BIG, BUT WE USE THE SAME BRAND

TO BE A FLY ON THIS VOICE MEMO WALL

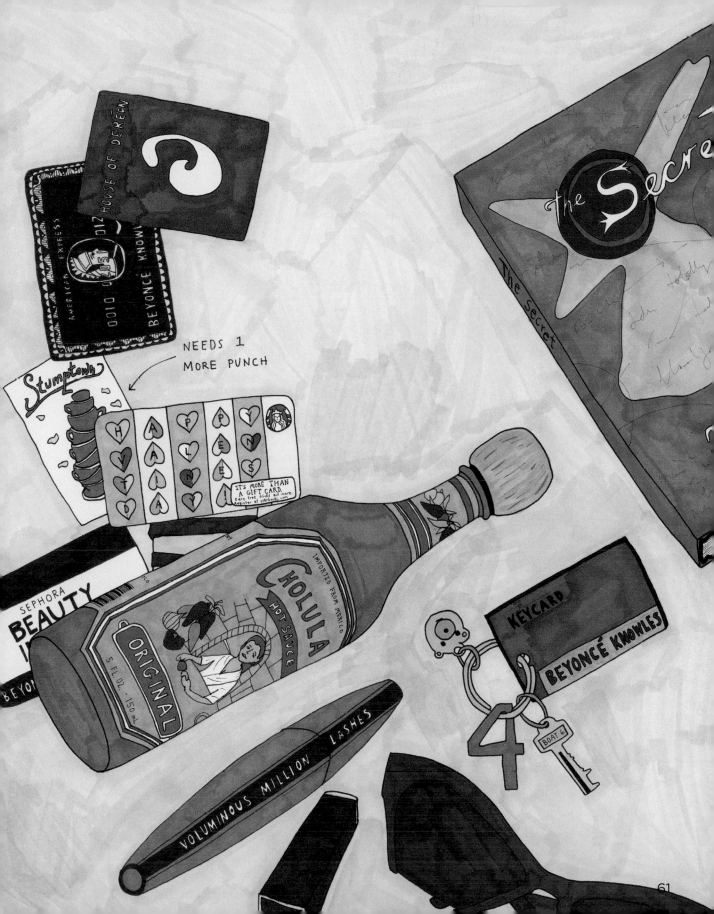

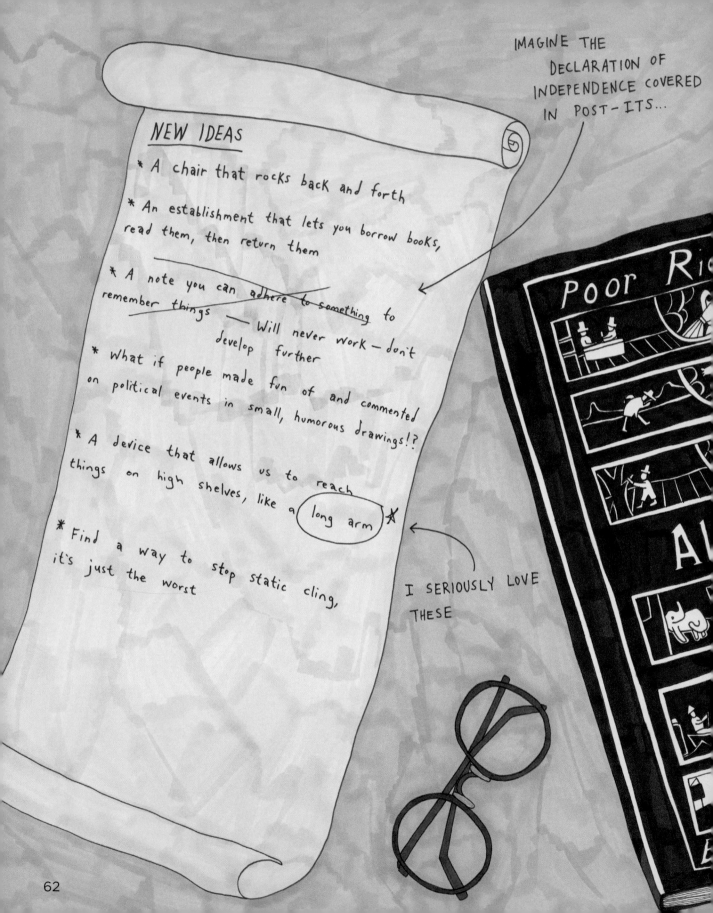

IMAGE THE DECLARATION OF INDEPENDENCE COVERED IN POST-ITS...

NEW IDEAS

* A chair that rocks back and forth

* An establishment that lets you borrow books, read them, then return them

* A note you can adhere to something to remember things — Will never work — don't develop further

* What if people made fun of and commented on political events in small, humorous drawings!?

* A device that allows us to reach things on high shelves, like a (long arm) ✗

* Find a way to stop static cling, it's just the worst

I SERIOUSLY LOVE THESE

Poor Ri
A

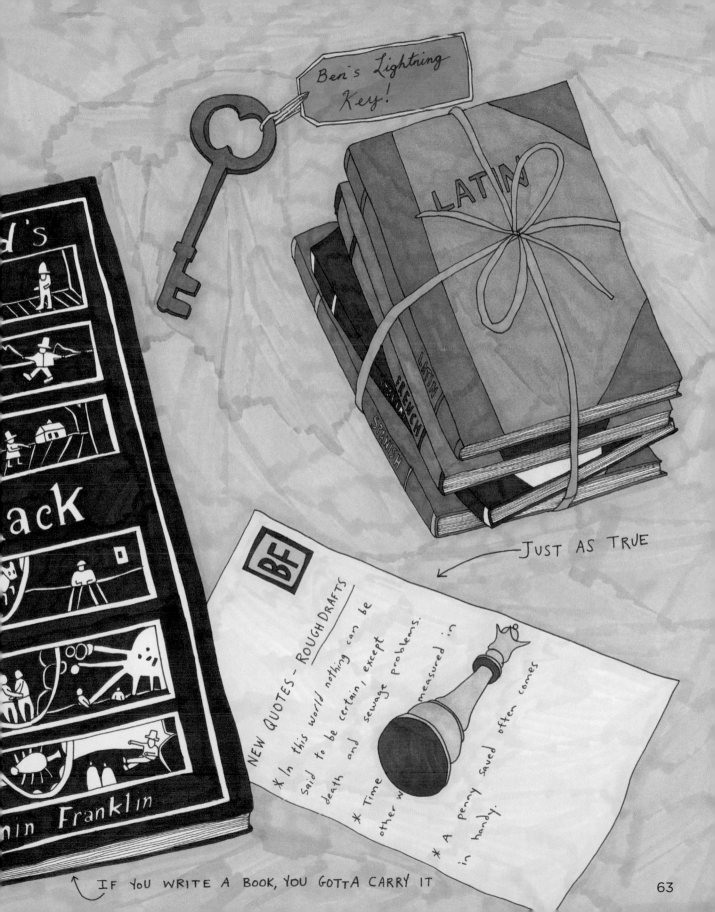

Ben's Lightning Key!

LATIN

LATIN
FRENCH
SPANISH

's

ack

Franklin

nin Franklin

↑ IF YOU WRITE A BOOK, YOU GOTTA CARRY IT

JUST AS TRUE

BF

NEW QUOTES - ROUGH DRAFTS

* In this world nothing can be said to be certain except death and sewage problems.

* Time measured in other w...

* A penny saved often comes in handy.

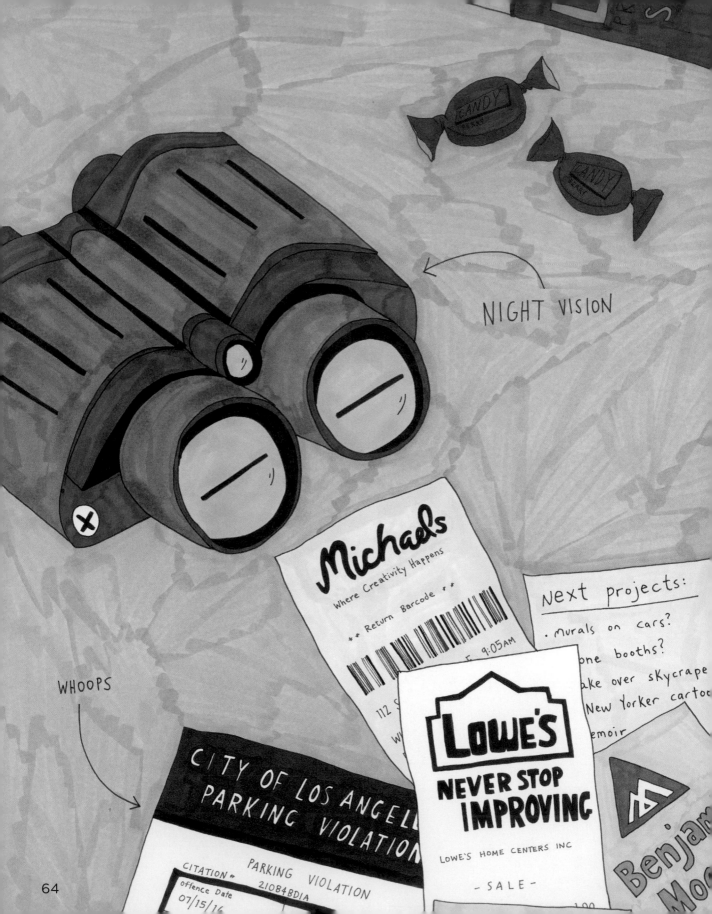

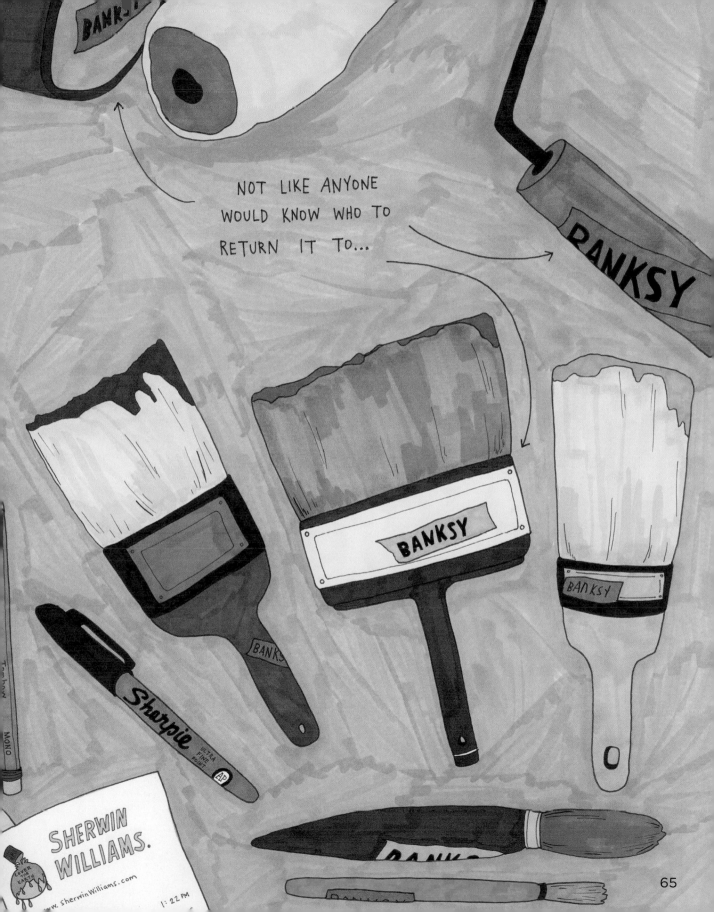

Legal Pad

I rise once again even though

AND STILL I RISE

TO BE HER HOTEL
STAFF...

HOTEL STAFF

Ms. Maya Angelou

ROOM
7

HOTEL

A ROOM OF ONE'S
OWN

ORIGINAL
INSPO.

THE OXFORD ENGLIS...

ROGE Internot...
THESAU...

THE
HOLY
BIBLE

FIELD NOTES

POCKET DICTIONARY

LITTLE BLACK BOOK

POETRY DEEP DARK

TRAVEL GUIDE

HOW TO: LIVE LIFE

PERSONAL DIARY

KEEP OUT!

PLAY MORE.
WORK LESS.

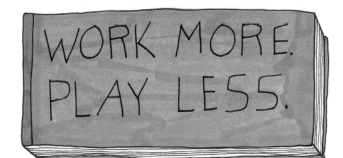

WORK MORE.
PLAY LESS.

HOW
TO:
LIVE
LIFE
BETTER

HOW
TO:
LIVE
LIFE
THE
BEST

SELF
HELP

BY: ANYONE

STUDY
GUIDE:
TEST PREP
FOR
IMPOSSIBLY
COMPLICATED TESTS THAT
MATTER SO SO MUCH RIGHT NOW
IN THIS MOMENT + THEN WILL
BECOME ABSOLUTELY MEANINGLESS.

FOOD MAP

BEST-SELLING
NOVEL
THAT
EVERY SINGLE
PERSON IS
CURRENTLY TALKING
ABOUT

MAP

BIKE MAP

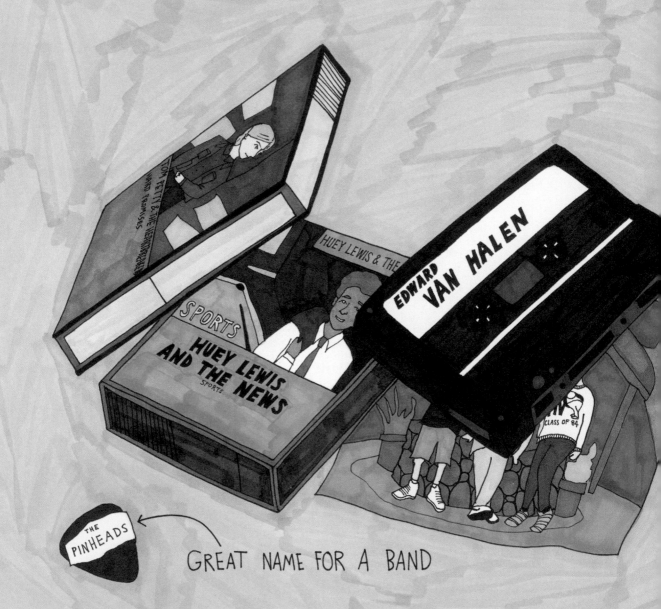

GREAT NAME FOR A BAND

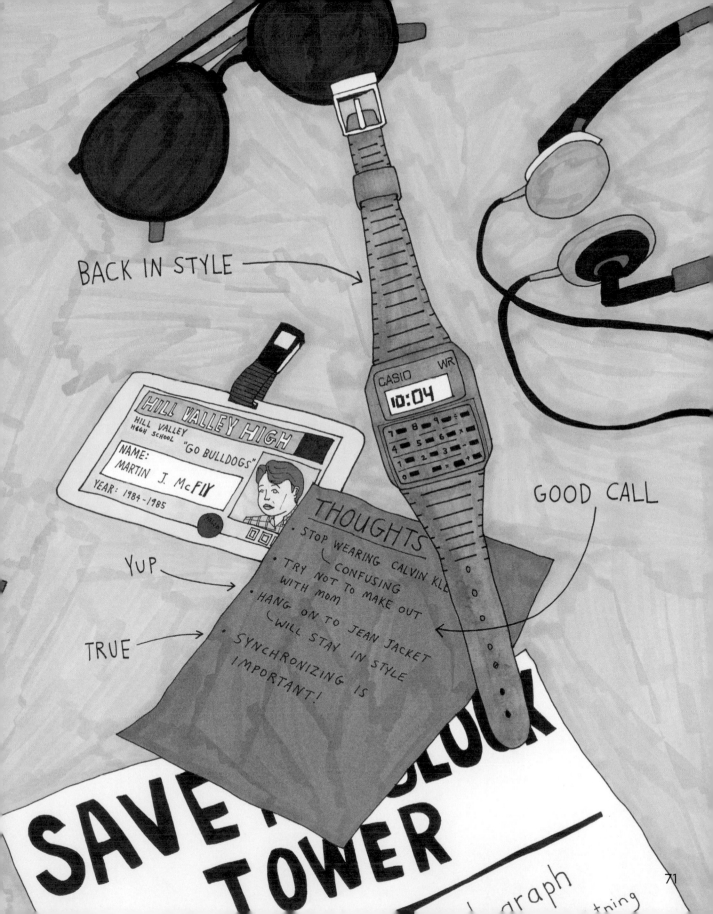

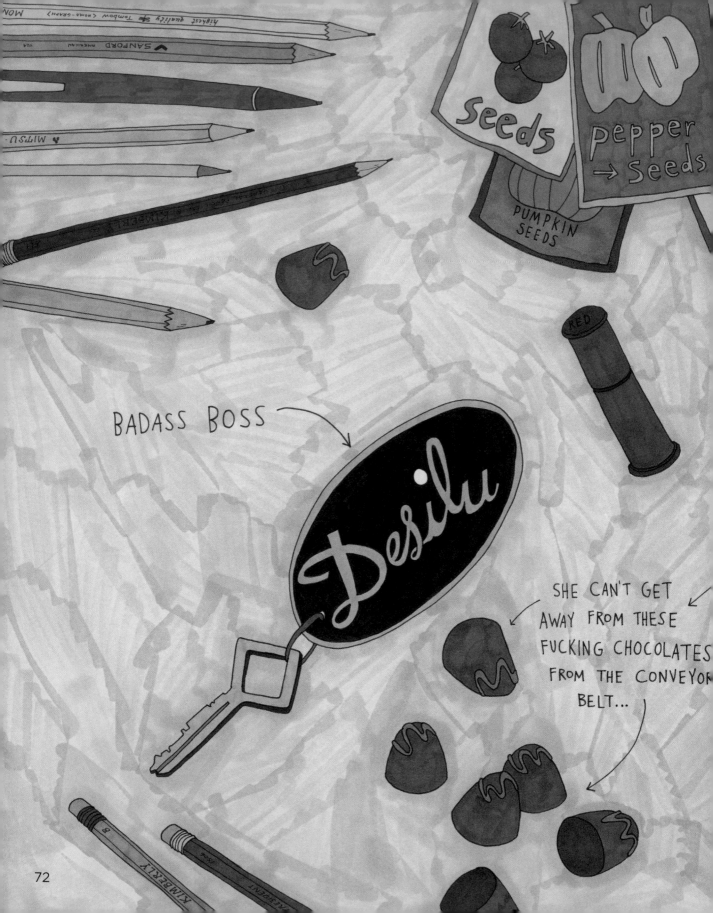

GLESS BEANS

I GUESS I DIDN'T
NEED TO DRAW THEM.
MY BAD.

SHE HAD A LOT
OF PENCILS

PACKING INFORMATION –
(TIPS / COOL IDEAS)

+ IF YOU PACK NICE SHIRTS (SOMETHING YOU'D DRY-CLEAN) YOU CAN ROLL THEM INSTEAD OF FOLDING SO THERE'S NO WRINKLES!

 ← MOM ADVICE

+ LESS IS MORE: NO ONE CARES IF YOU WEAR THE SAME THING MORE THAN ONCE.

 EVEN THOUGH WE FEEL THE NEED TO POINT IT OUT TO EVERYONE IN CASE THEY DID NOTICE

+ WHEN IN DOUBT, WEAR SNEAKERS

 SO YOU SHOULD PACK 'EM!

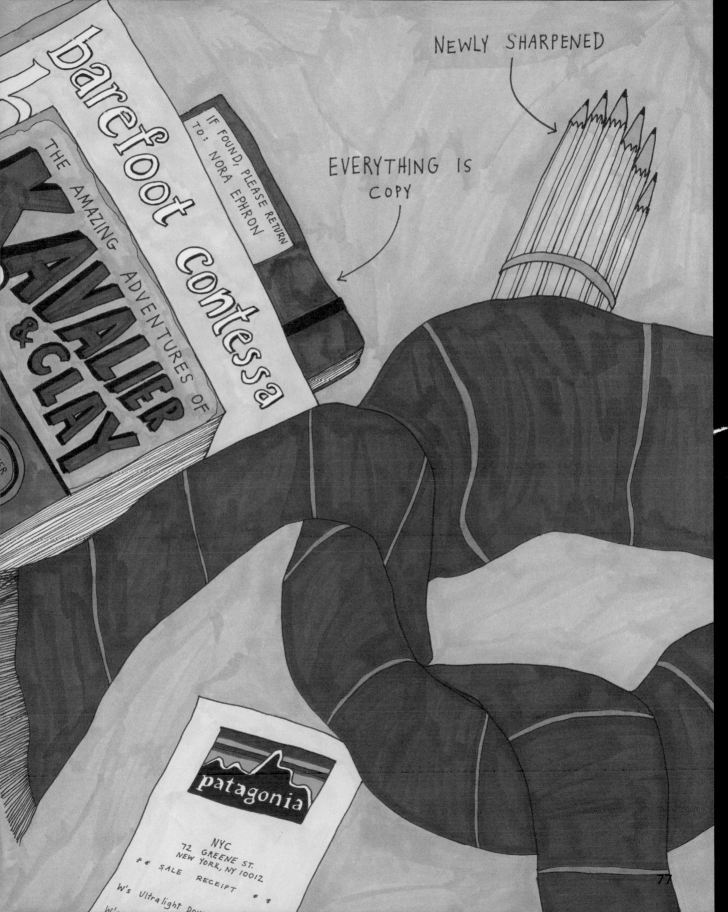

BUTTERSCOTCH
CLOUDS

TANGERINE

STARFISH

THE ARTIST FORMERLY KN

MAPLE SYRUP

COFFEE

JAM PEACH

SIDE ORDER
OF HAM

PRINCE

FOR
MUSTACHE

FOR THE DOVE SHED

THIS IS THE KEY

D.S.

PAISLEY PARK

THIS HAD TO BE PIXILATED
...LEGAL

MASCARA

OBSERVATIONS FROM EARTH

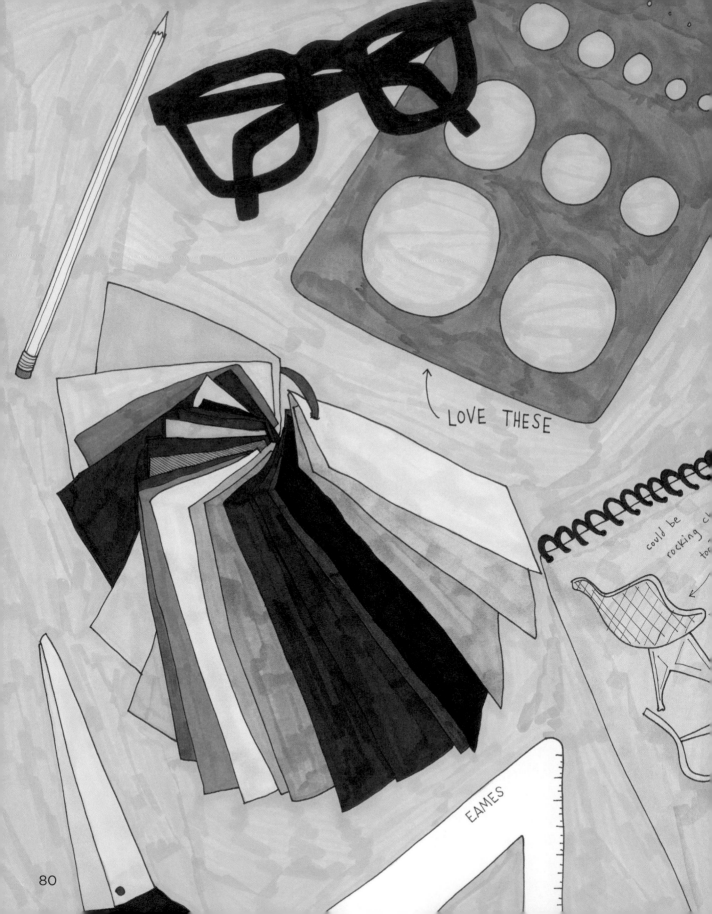

LOVE THESE

could be
rocking ch
to

EAMES

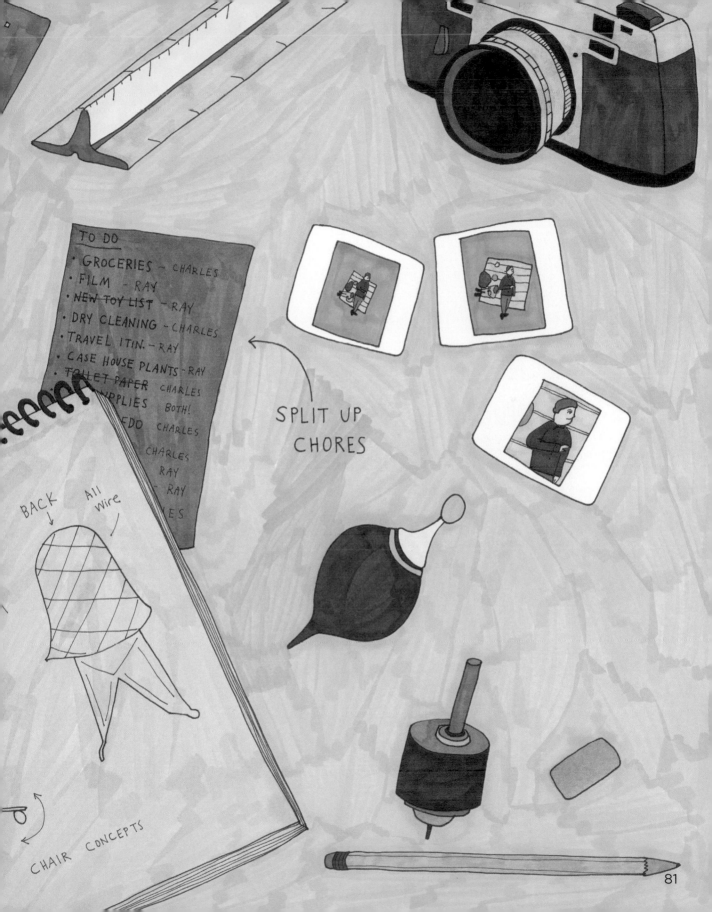

TO DO
- GROCERIES - CHARLES
- FILM - RAY
- NEW TOY LIST - RAY
- DRY CLEANING - CHARLES
- TRAVEL ITIN. - RAY
- CASE HOUSE PLANTS - RAY
- TOILET PAPER - CHARLES
- SUPPLIES - BOTH!
- FEDD - CHARLES
- CHARLES
- RAY
- RAY
- ES

SPLIT UP
CHORES

BACK All
 wire

CHAIR CONCEPTS

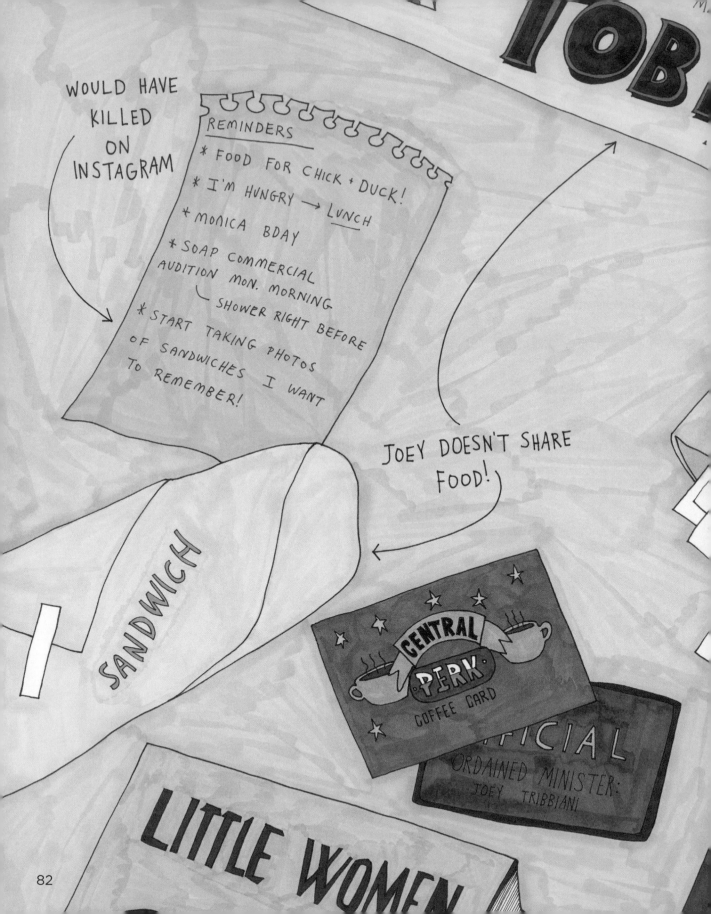

WOULD HAVE KILLED ON INSTAGRAM

REMINDERS
* FOOD FOR CHICK + DUCK!
* I'M HUNGRY → LUNCH
* MONICA BDAY
* SOAP COMMERCIAL AUDITION MON. MORNING
 ↳ SHOWER RIGHT BEFORE
* START TAKING PHOTOS OF SANDWICHES I WANT TO REMEMBER!

JOEY DOESN'T SHARE FOOD!

SANDWICH

CENTRAL PERK COFFEE CARD

FICIAL ORDAINED MINISTER: JOEY TRIBBIANI

LITTLE WOMEN

TOB

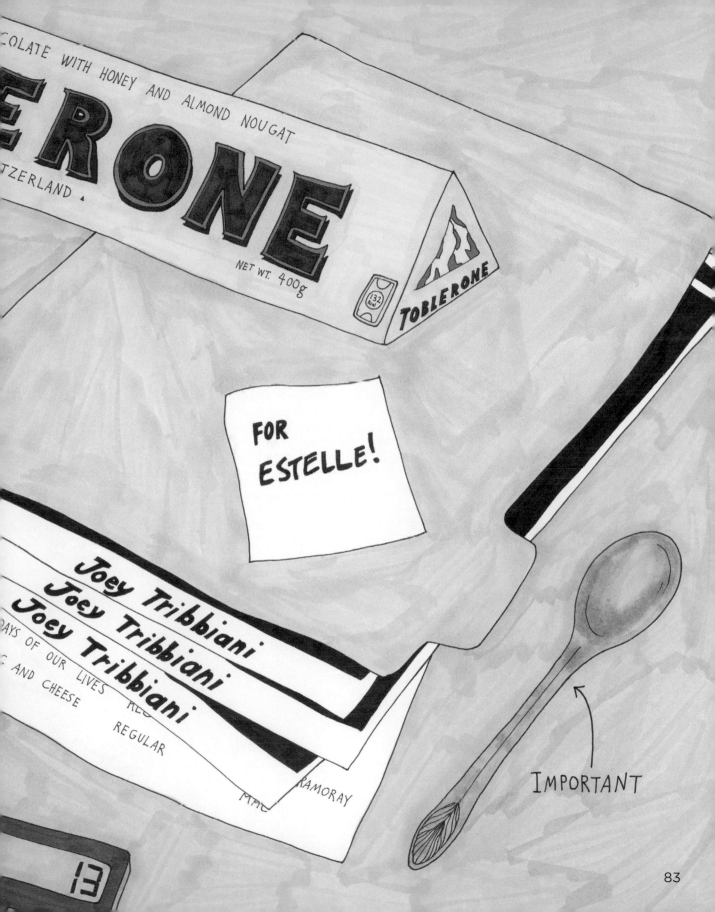

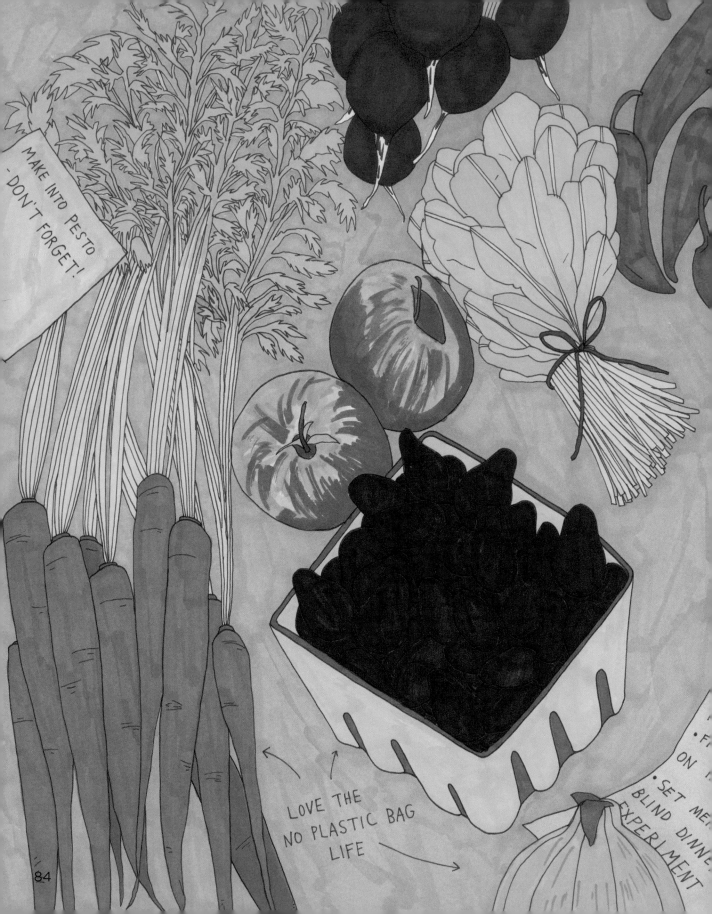

MAKE INTO PESTO
- DON'T FORGET!

LOVE THE
NO PLASTIC BAG
LIFE

SET ME
BLIND DINNE
EXPERIMENT

84

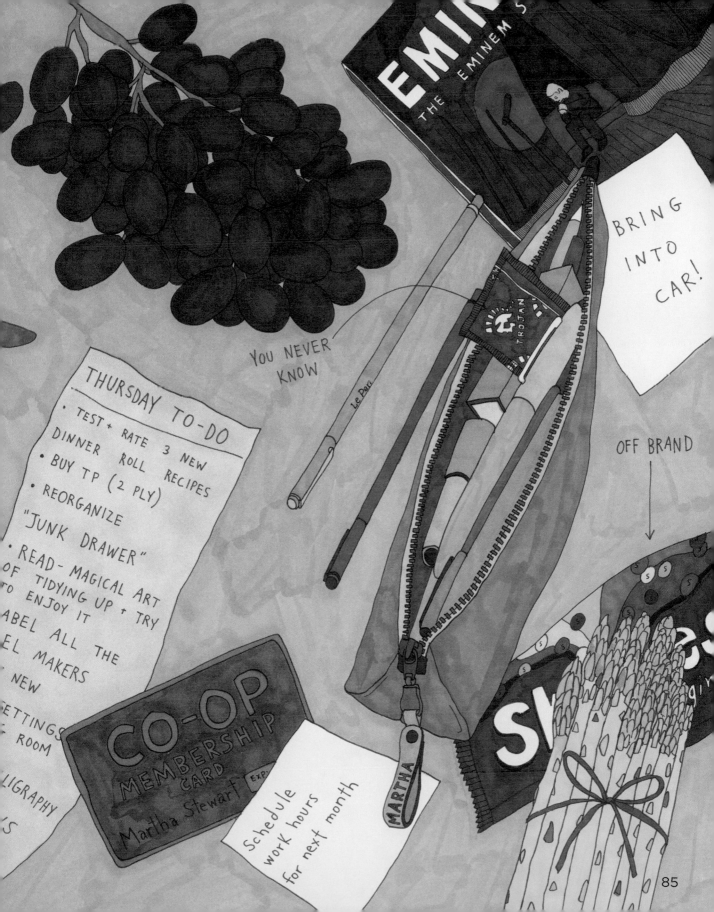

THURSDAY TO-DO

- TEST + RATE 3 NEW DINNER ROLL RECIPES
- BUY TP (2 PLY)
- REORGANIZE "JUNK DRAWER"
- READ - MAGICAL ART OF TIDYING UP + TRY TO ENJOY IT
- ABEL ALL THE EL MAKERS
- NEW
- ETTINGS ROOM
- LIGRAPHY
- S

YOU NEVER KNOW

BRING INTO CAR!

OFF BRAND

Le Pen

TROJAN

MARTHA

EMIN
THE EMINEM S

CO-OP MEMBERSHIP CARD
Martha Stewart Exp.

Schedule work hours for next month

S

85

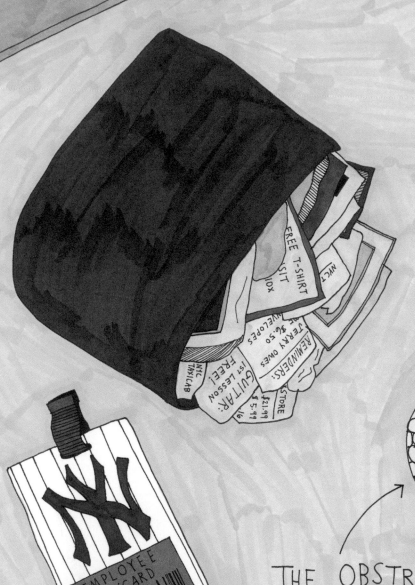

THE OBSTRUCTION

WHAT TO CARRY:

TIP #2

MY MUST LIST

- A PEN
- SOME SORT OF NOTEBOOK
- HEADPHONES
- LIP GLOSS
- METROCARD
- AN OPEN MIND

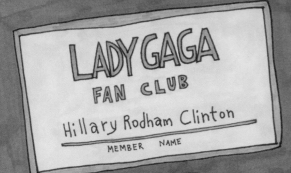

LADY GAGA
FAN CLUB

Hillary Rodham Clinton

MEMBER NAME

PRACTICE MAKES PERFECT

Hillary

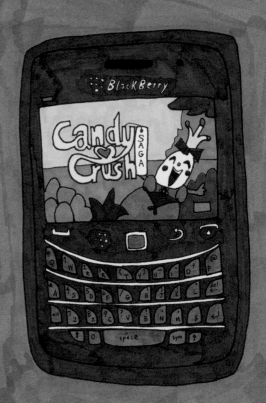

WHEN YOU'RE MAKING HISTORY, YOU HAVE TO KNOW
WHERE WE'VE BEEN
TO KNOW WHERE WE NEED TO GO

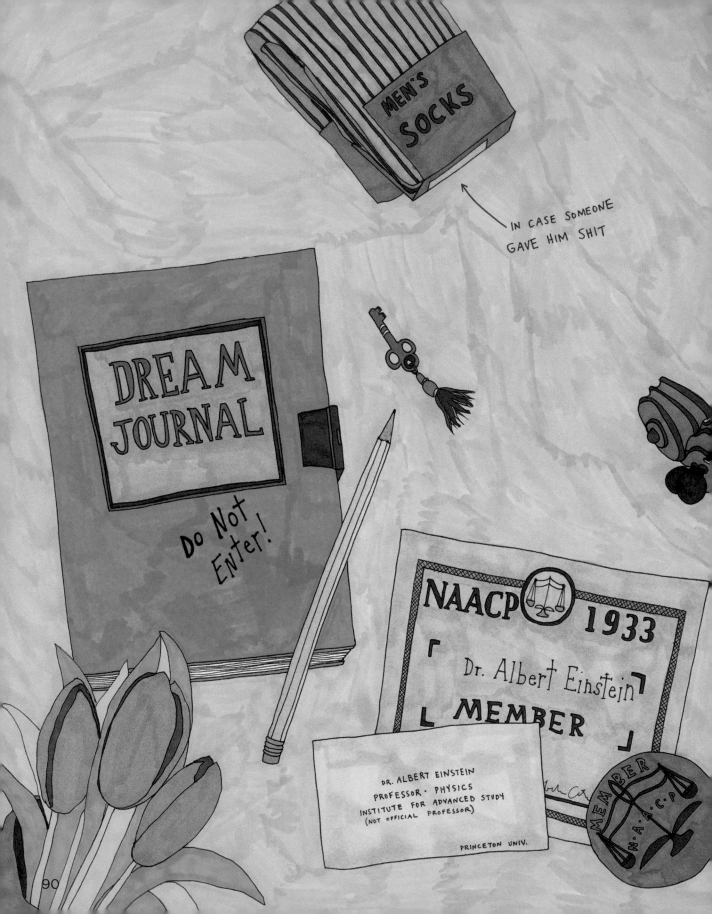

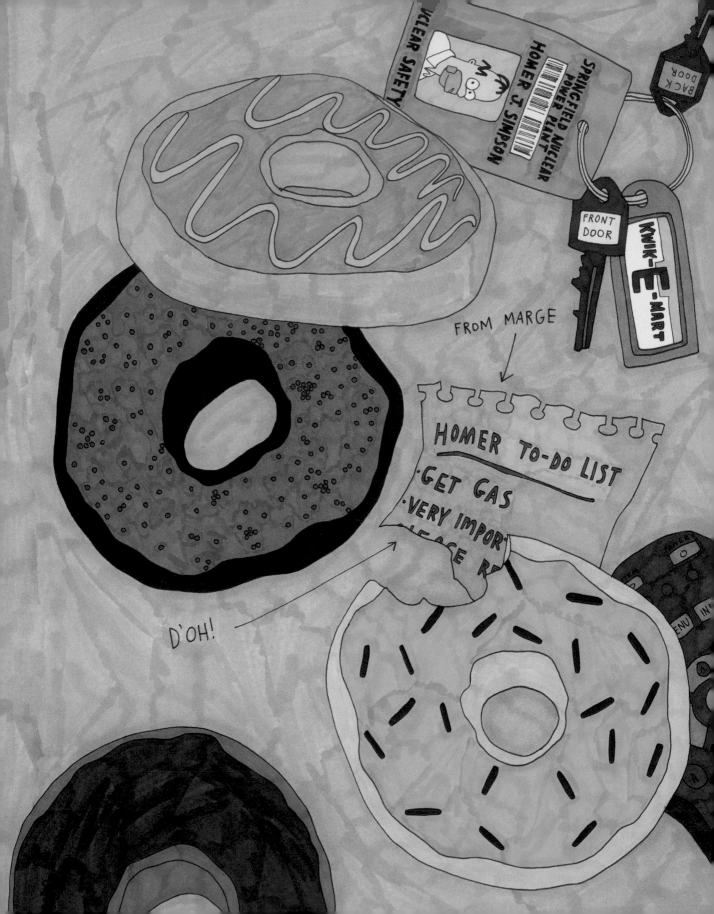

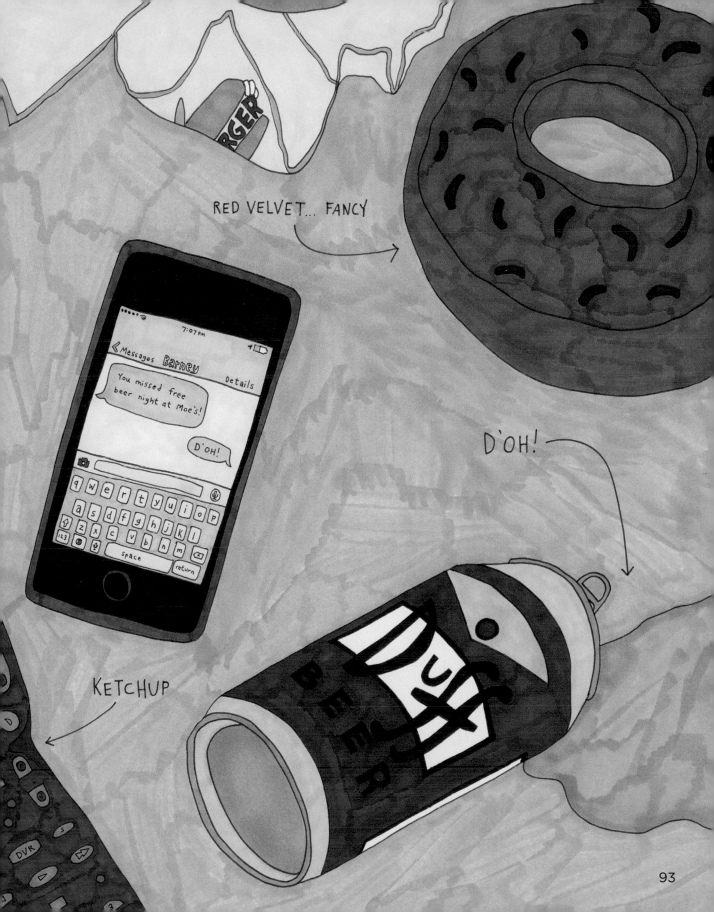

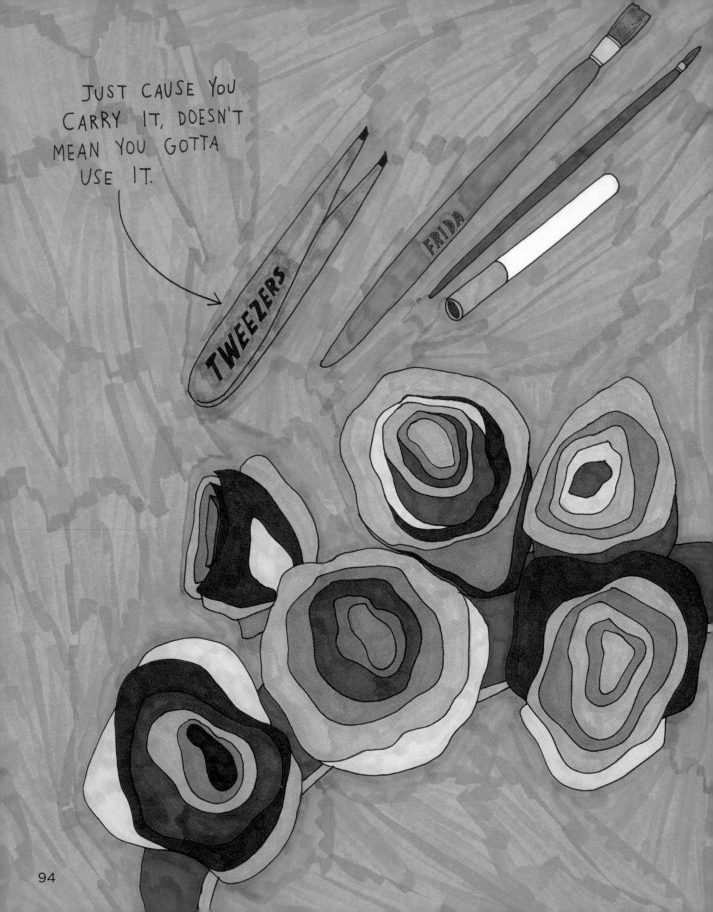

GROWTH OF PEOPLE TAKING + NEVER COMPLETING EVERY SINGLE COFFEE SHOP PUNCH CARD THEY COME IN CONTACT WITH:

ALMOST EVERYONE

MORE THAN NOT

A TON OF PEOPLE

SO MANY PEOPLE

FEW PEOPLE

NO ONE

BEGINNING OF TIME

PRESENT DAY

IMPORTANT FACTS

THIS MARKER DRIED OUT ON ME

95

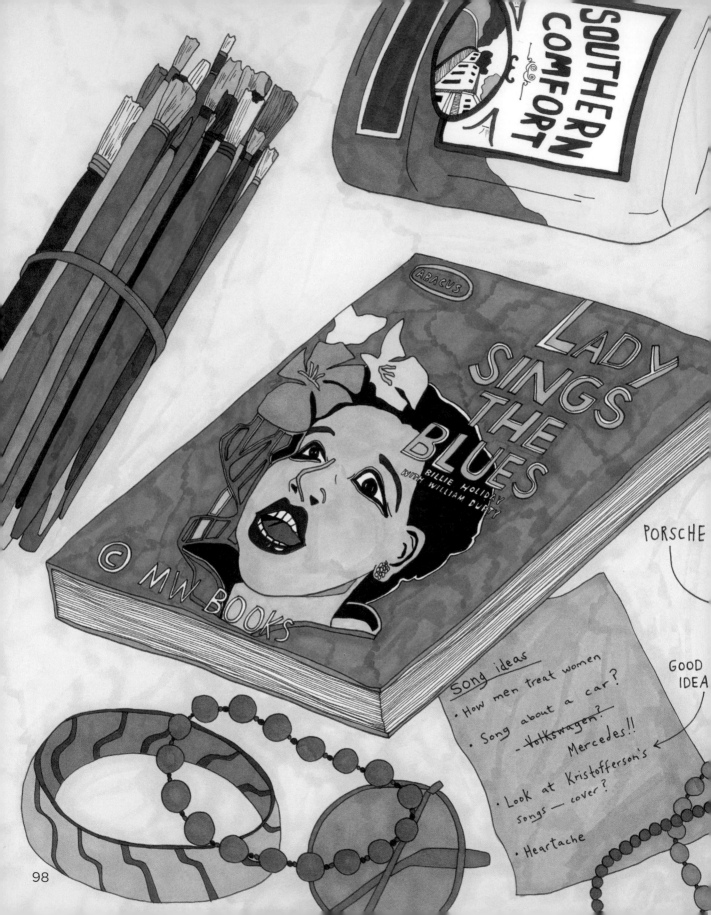

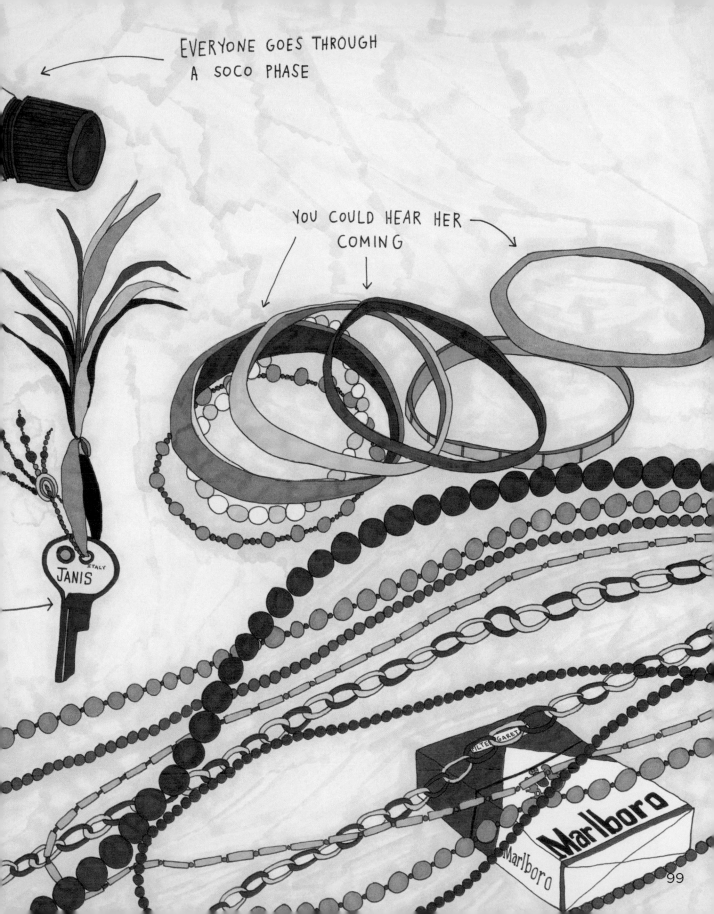

EVERYONE GOES THROUGH A SOCO PHASE

YOU COULD HEAR HER COMING

JANIS

Marlboro

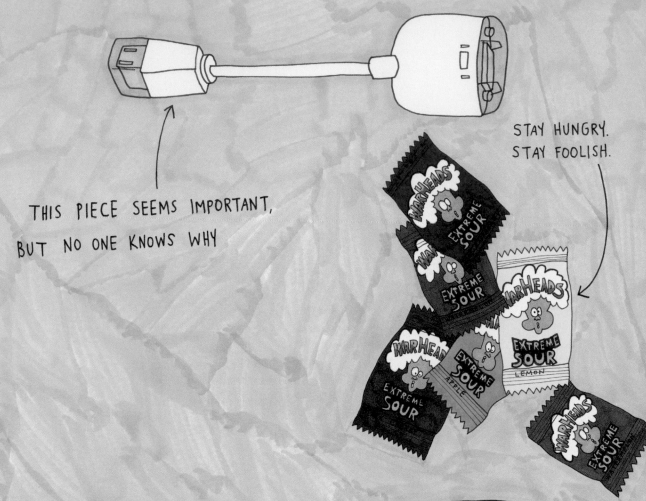

THIS PIECE SEEMS IMPORTANT,
BUT NO ONE KNOWS WHY

STAY HUNGRY.
STAY FOOLISH.

new balance vip card
steve Jobs

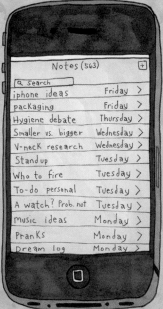

Notes (563)

iphone ideas	Friday >
packaging	Friday >
Hygiene debate	Thursday >
Smaller vs. bigger	Wednesday >
V-neck research	Wednesday >
Standup	Tuesday >
Who to fire	Tuesday >
To-do personal	Tuesday >
A watch? Prob. not	Tuesday >
Music ideas	Monday >
Pranks	Monday >
Dream log	Monday >

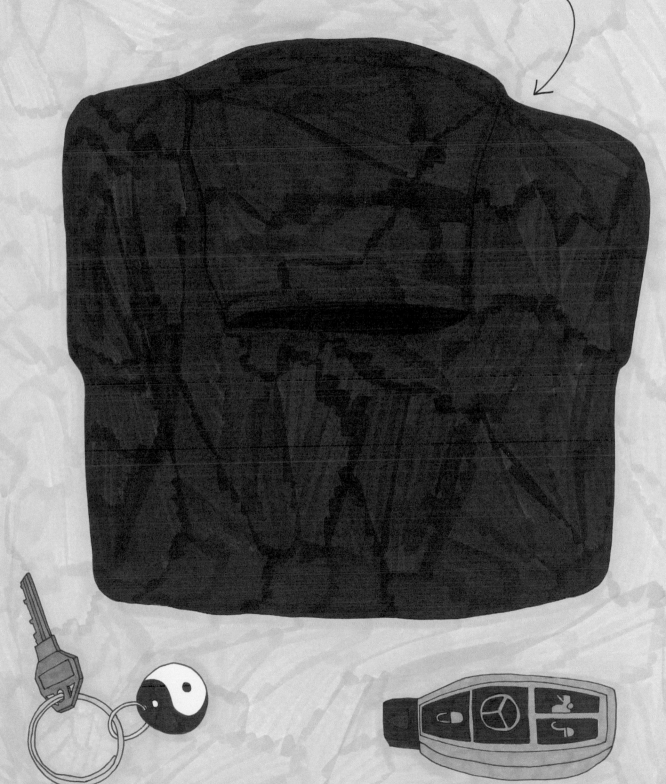

SPARE TURTLE

STAND UP

VISION BOARD #2

BEATS

NOVEL

FIONA APPLE

BUSINESS

ART

SAMPLES

RANTS

TWEET ARCHIVE

MISC.

TO DO

SNEAKERS

DON'T DO

CULINARY INSPO.

FAMILY
STUFF

DOODLES

FABRICS

COLOR
INSPO.

TAXES

DREAM
JOURNAL

512 GB

KANYE

PABLO

VISION
BOARD #3

TRAVEL
IDEAS

PUPPIES

PATTERNS

NEW
NICKNAMES

VISION
BOARD #1

PHOTOS

PONDERING
CHUNKY
WALLETS...

A LOT OF GUYS CARRY THEIR WALLETS
IN THEIR POCKETS.

LOOK AT THIS BULLSHIT
MISTAKE... SOMETIMES
I WONDER WHAT'S
HAPPENING WITH MY
BRAIN.

I HAVE SOME QUESTIONS:

1. HOW DO YOU DO THIS?

2. AREN'T YOU ALWAYS AWARE OF
 THIS CHUNK?

3. DO YOU CONSTANTLY MANAGE
 THE CONTENTS TO KEEP THE
 WEIGHT DOWN?

USUALLY WE WOULD
EDIT THIS STUFF,
BUT INSTEAD, THI
IS A REAL
GLIMPSE
BEHIND THE
CURTAIN.

UGH. MAYBE WE SHOULD HAVE JUST CHANGED THE "K"

104

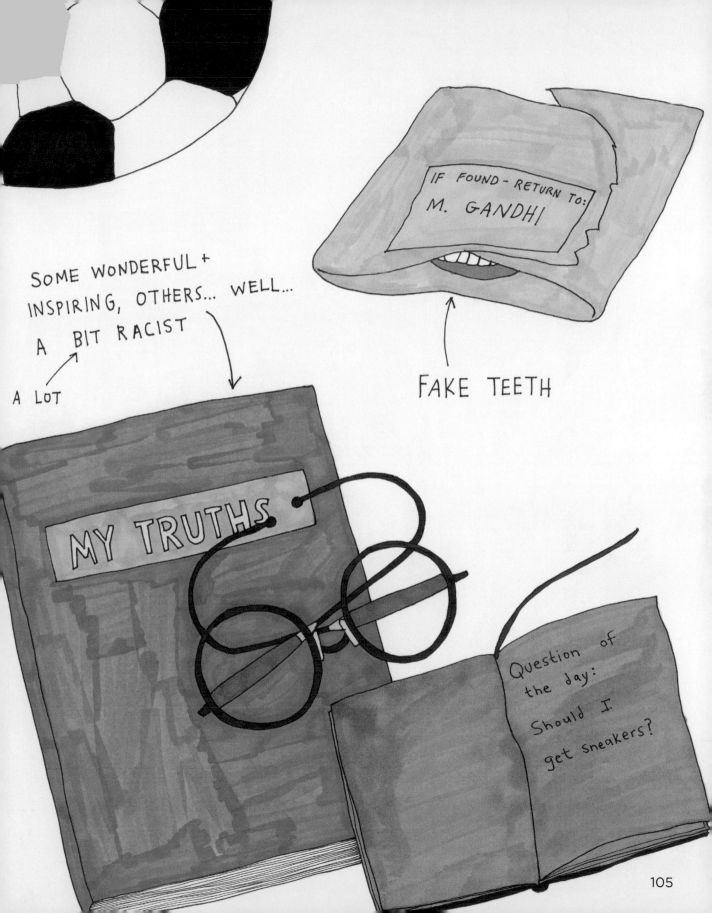

SOME WONDERFUL +
INSPIRING, OTHERS... WELL...
A BIT RACIST

A LOT

IF FOUND - RETURN TO:
M. GANDHI

FAKE TEETH

MY TRUTHS

Question of
the day:
Should I
get sneakers?

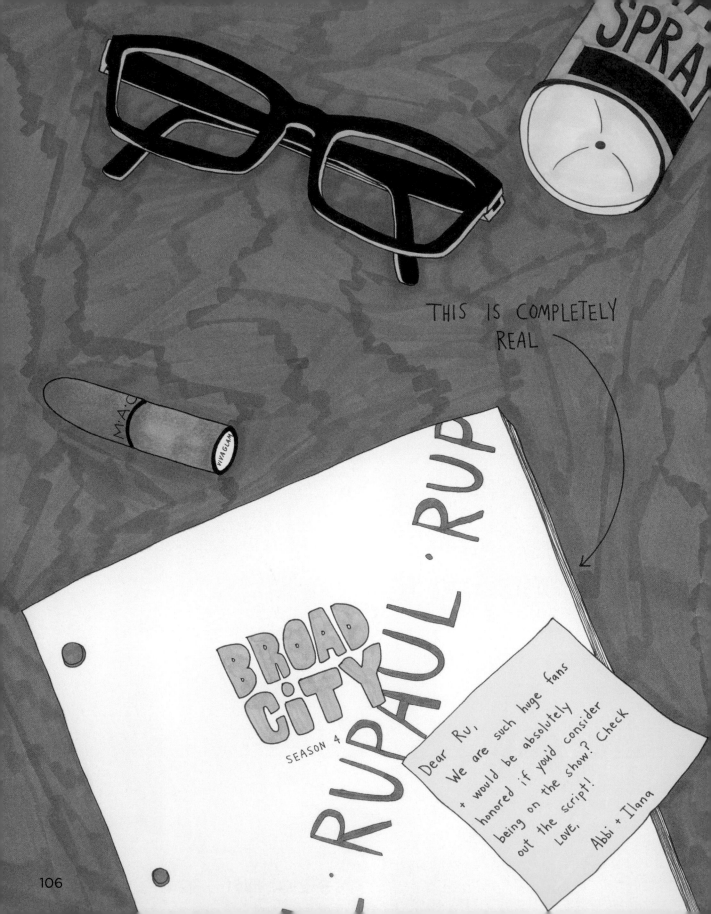

THIS IS COMPLETELY REAL

BROAD CITY

RUPAUL · RUPAUL · RUP

SEASON 4

Dear Ru,
We are such huge fans
+ would be absolutely
honored if you'd consider
being on the show? Check
out the script!
Love,
Abbi + Ilana

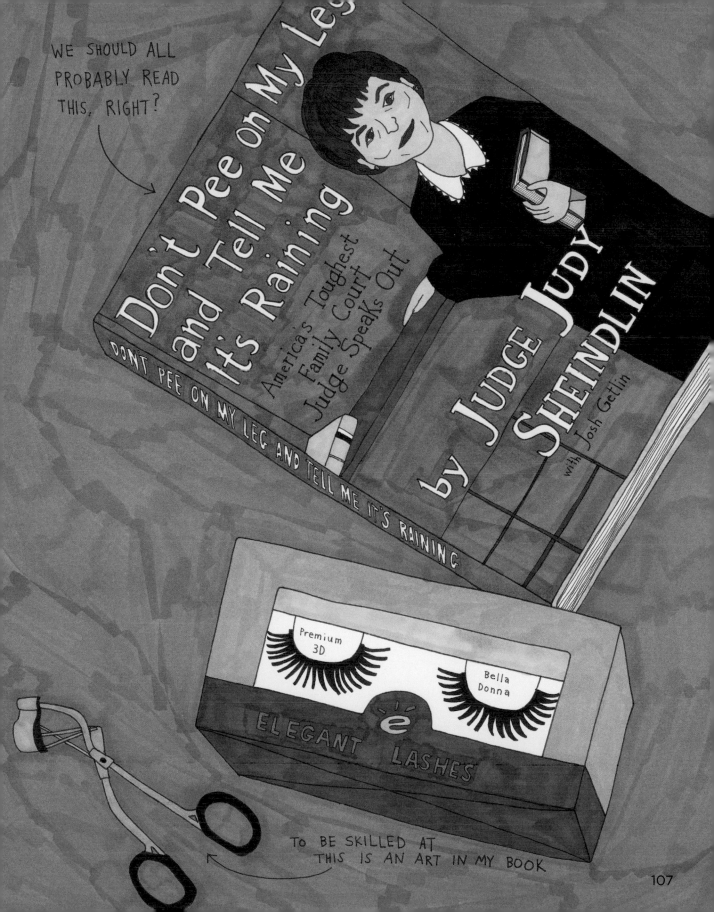

PEE-WEE'S TO-DO LIST

- Order new pocket squares
- FRESH DIRECT!
- GET SPECK NEW TOY
- PLOT REVENGE ON FRANCIS
 ↳ PUT INTO ACTION
- CLEAN BICYCLE/WAX
- DRY CLEANING
- MOVE "TEQUILA" FROM itunes
 ON LAPTOP TO iphone ← icloud?
- CATCH UP WITH DOTTIE
- FINALLY WATCH
 "THE BICYCLE THIEF"

PART OF MORNING ROUTINE →

SO CLOSE TO BEING A TYPO
SAVED IT!

FUN

ALWAYS AN APPROPRIATE
WORD OF THE DAY

TRICK GUM

SLOW AND STEADY

ANOTHER CLOSE CALL

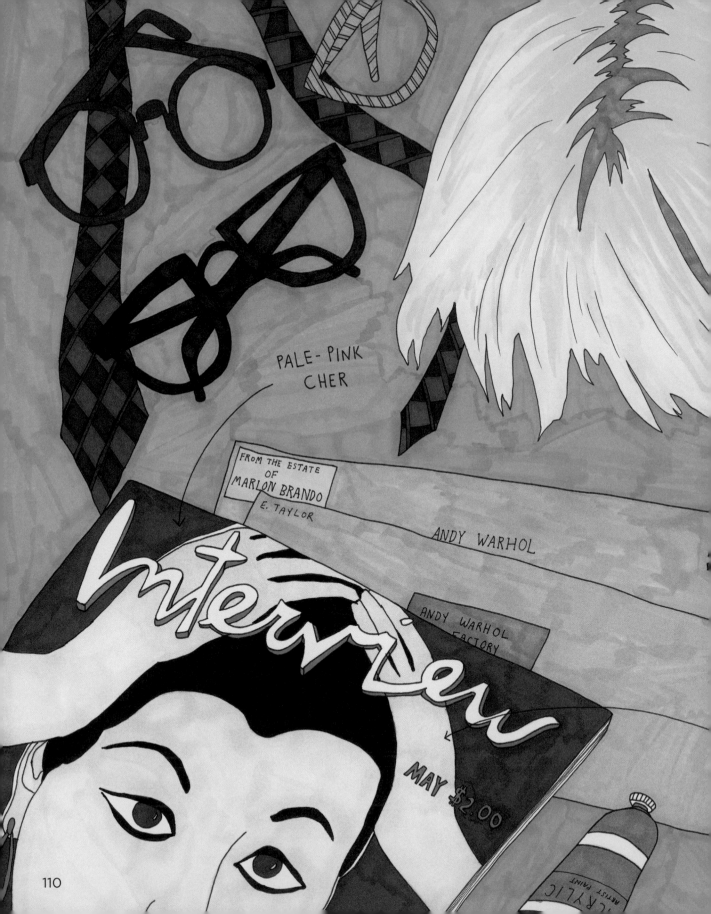

PALE-PINK
CHER

FROM THE ESTATE
OF
MARLON BRANDO
E. TAYLOR

ANDY WARHOL

ANDY WARHOL
FACTORY

Interview

MAY $2.00

ACRYLIC ARTIST PAINT

110

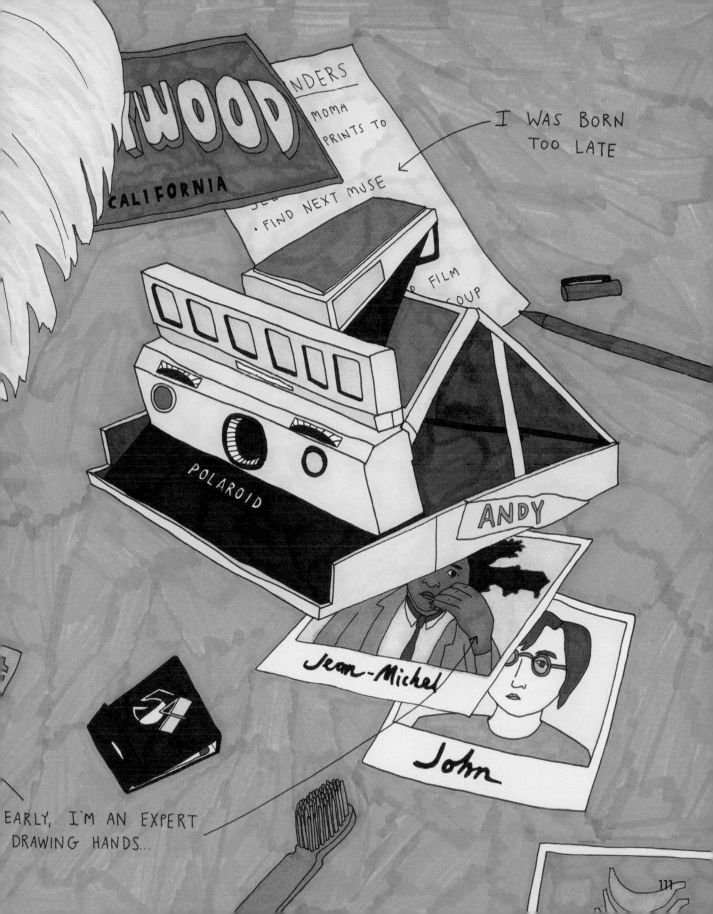

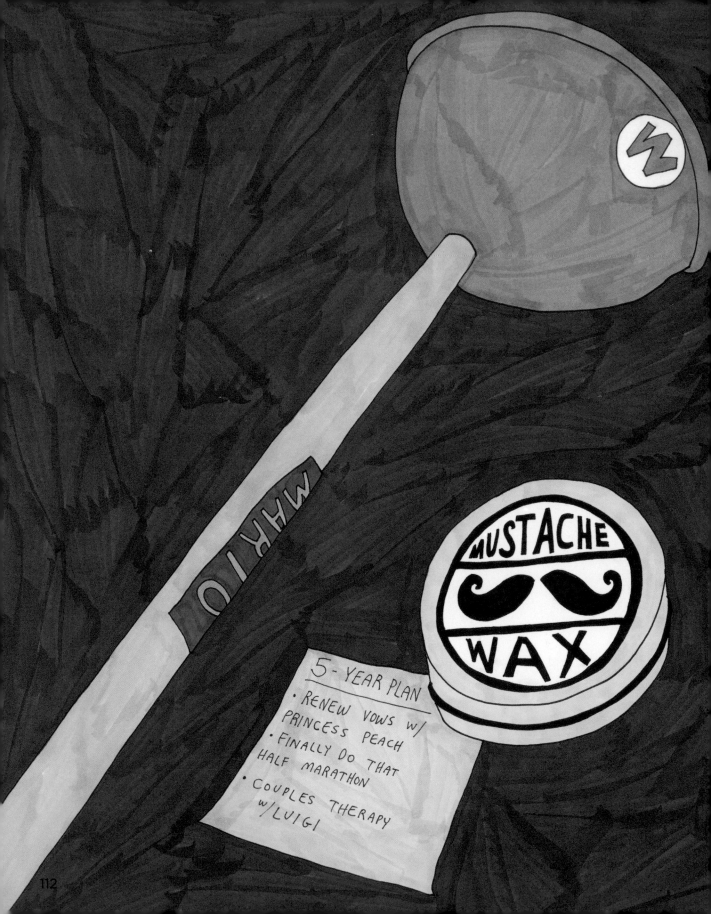

REMEMBER PACKING YOUR BOOKBAG
FOR THE FIRST DAY OF SCHOOL?

MINE STAYED
NEAT + ORGANIZED
FOR ABOUT A WEEK

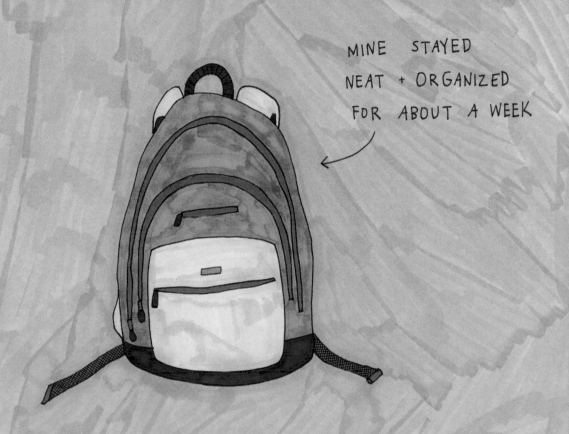

MY MOM WOULD TAKE MY BROTHER AND ME TO STAPLES
TO GET ALL THE ITEMS ON OUR LISTS. WE'D COME HOME
AND SPEND HOURS GETTING ORGANIZED -- ARRANGING

SCHOOL SUPPLIES ON THE FLOOR LIKE HALLOWEEN CANDY.

REALLY WILD CHILDREN...

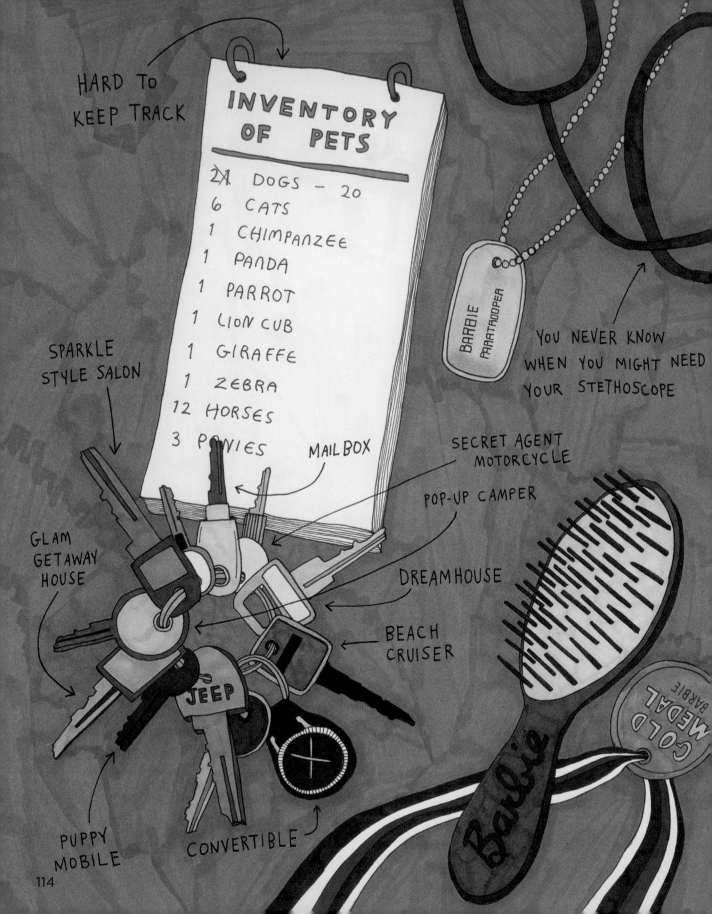

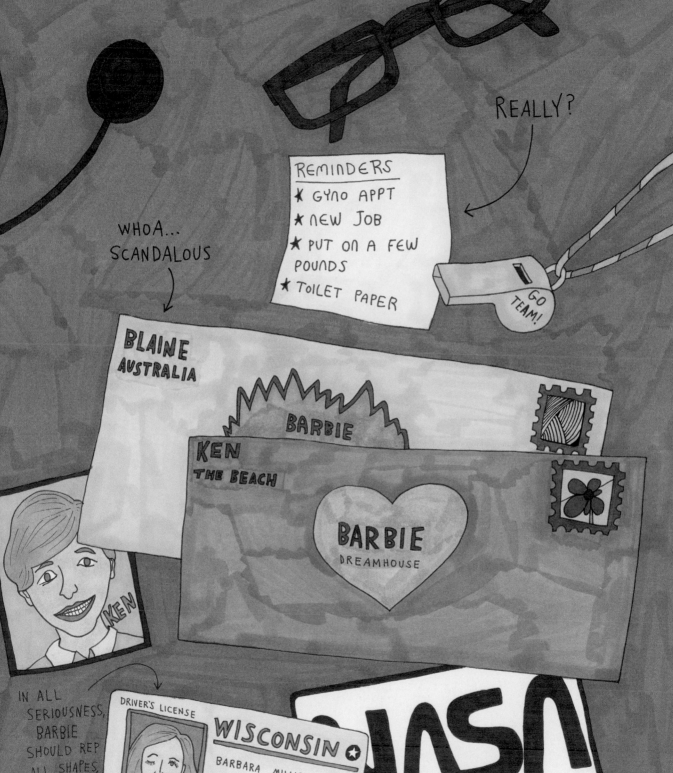

REALLY?

REMINDERS
★ GYNO APPT
★ NEW JOB
★ PUT ON A FEW POUNDS
★ TOILET PAPER

GO TEAM!

WHOA... SCANDALOUS

BLAINE AUSTRALIA

BARBIE

KEN THE BEACH

BARBIE DREAMHOUSE

KEN

IN ALL SERIOUSNESS, BARBIE SHOULD REP ALL SHAPES, COLORS + SIZES OF WOMEN AROUND THE WORLD.

DRIVER'S LICENSE
WISCONSIN ★
BARBARA MILLICENT ROBERTS
DOB: 03/09/1959
SEX: F
HAIR: BLONDE
EYES: BLUE
Barbie

NASA
ASTRONAUT CARD BARBIE

... EXCITED SHE HAS + IS EVOLVING

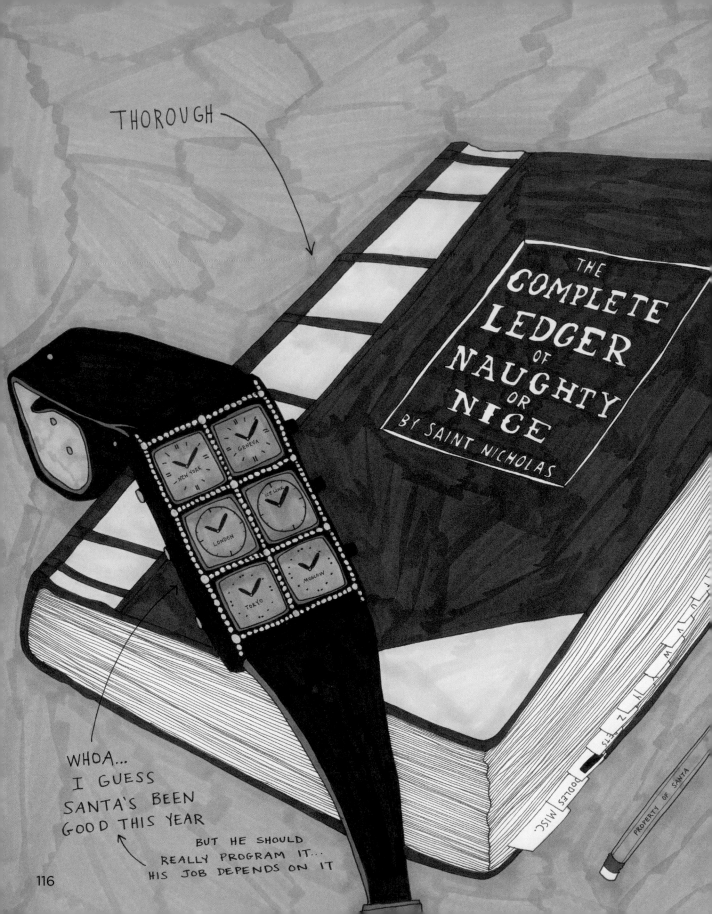

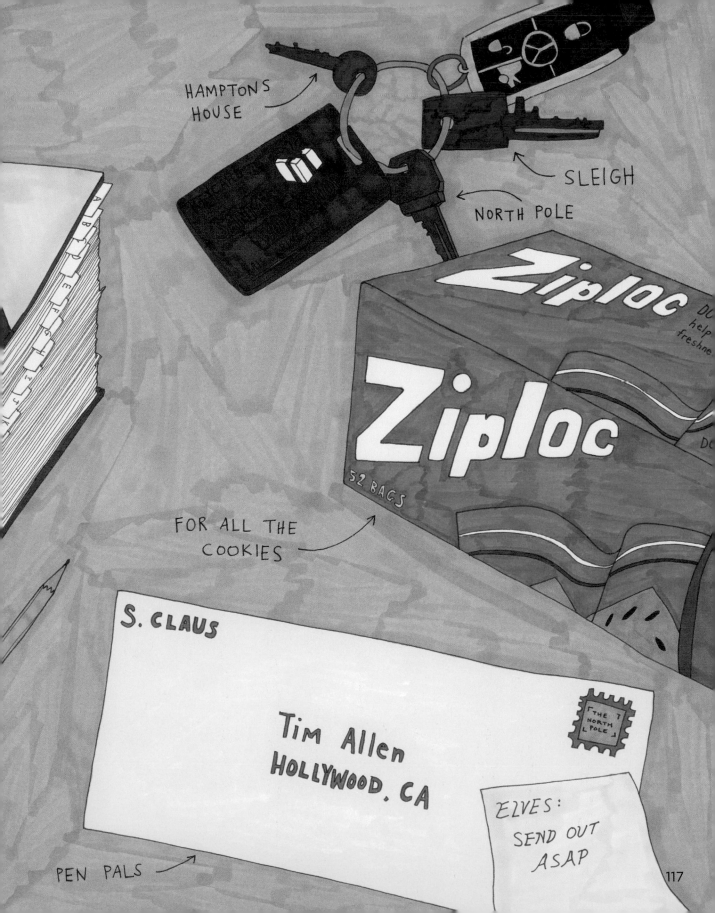

117

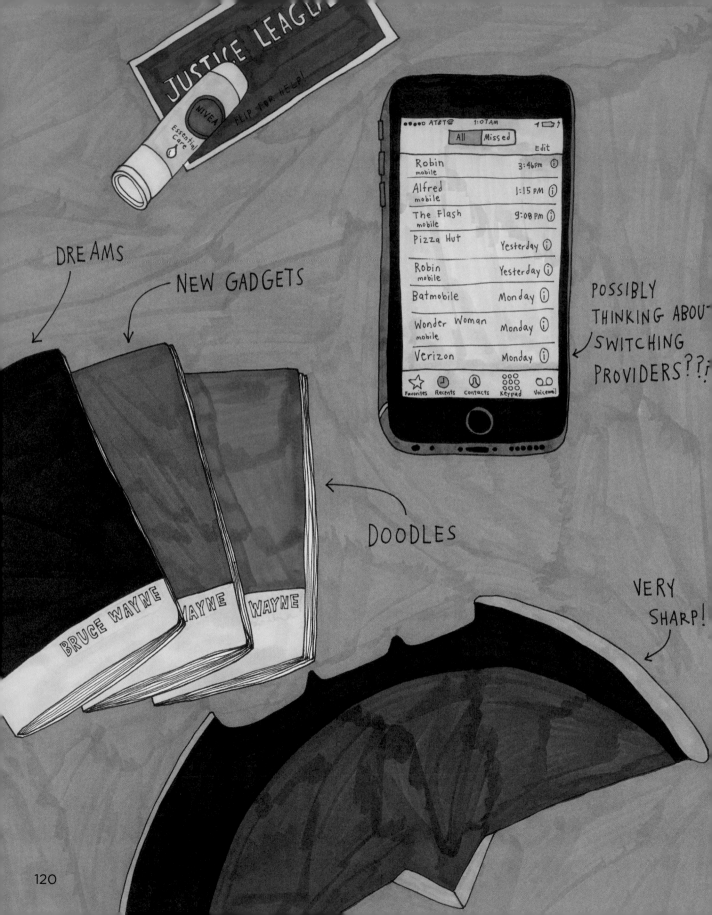

DO YOU CARRY ANYTHING FOR GOOD LUCK?

DO YOU CARRY THINGS IN CASE OF AN EMERGENCY?

DO YOU CARRY ANY PHOTOS?

DO YOU CARRY FIRST AID SUPPLIES?

DO YOU CARRY ANYTHING BECAUSE YOU'RE SUPERSTITIOUS?

DO YOU CARRY ANYTHING BECAUSE YOU'RE SCARED?

DO YOU CARRY ANY MEMORIES?

DO YOU CARRY ANYTHING INCRIMINATING?

DO YOU CARRY ANYTHING HILARIOUS?

DO YOU CARRY ANYTHING VALUABLE?

DO YOU CARRY ANYTHING HOLY?

DO YOU CARRY ANY SECRETS?

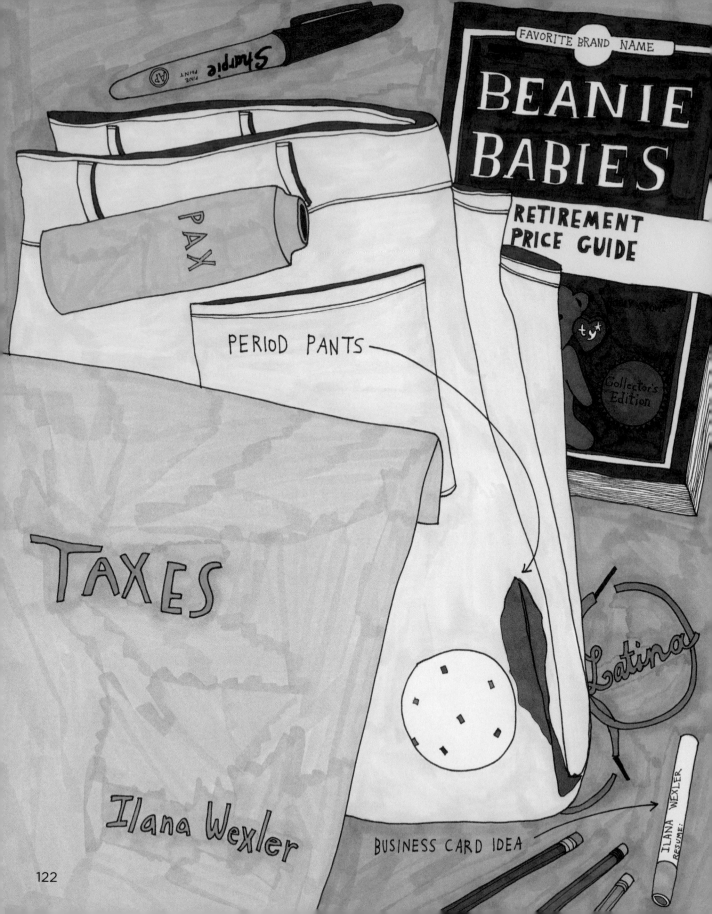

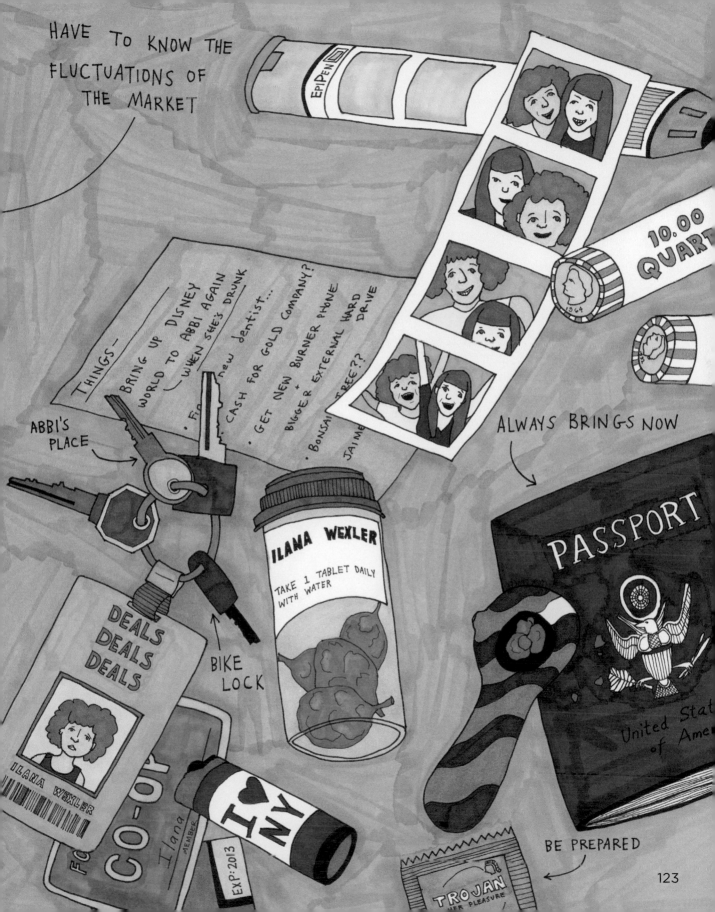

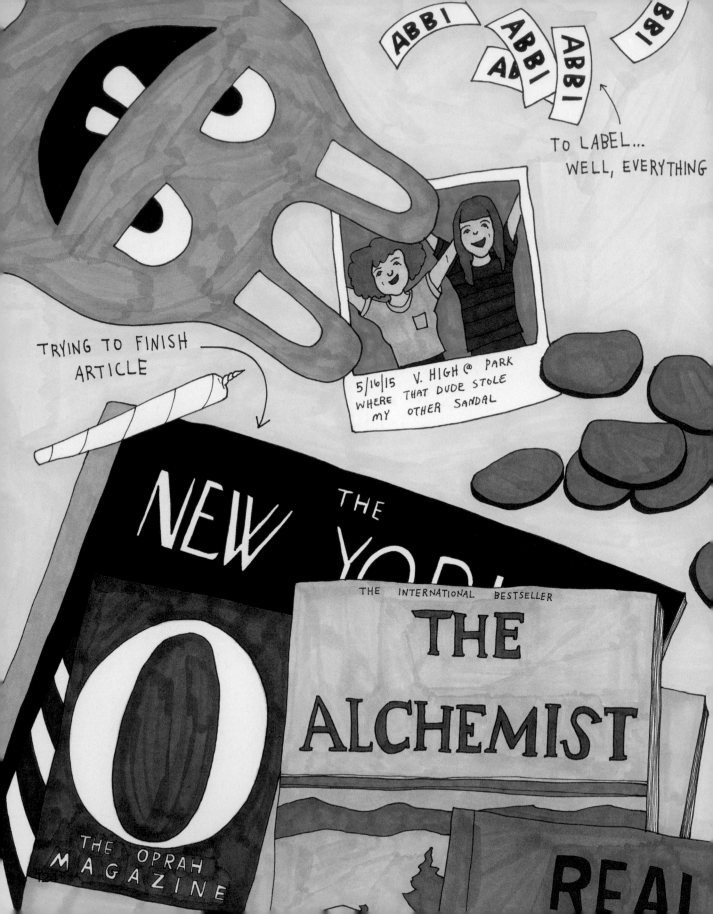

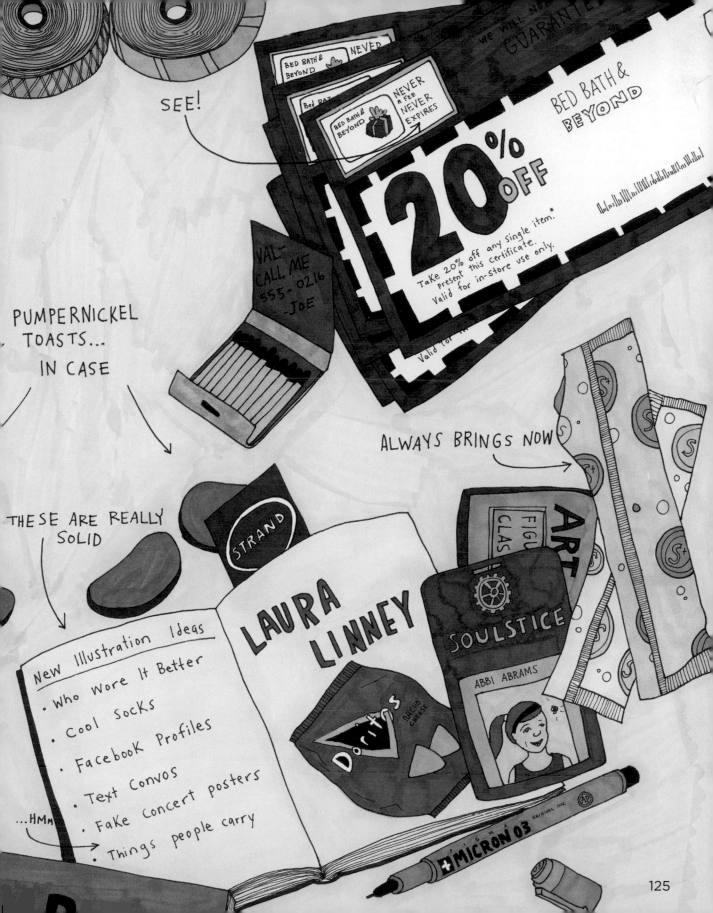

125

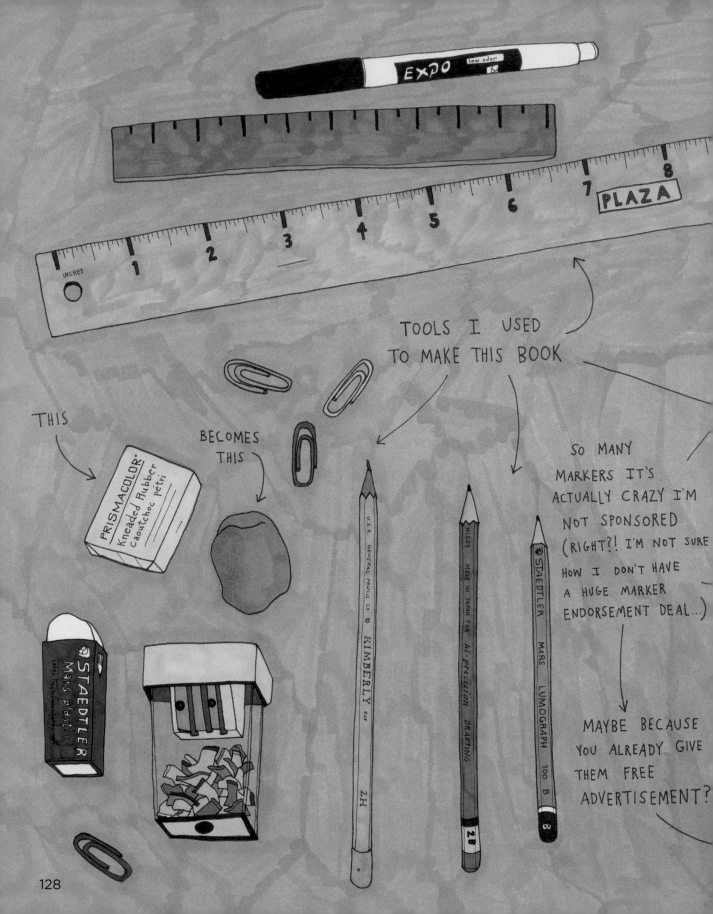

TOOLS I USED
TO MAKE THIS BOOK

EXPO low odor

PLAZA

8 7 6 5 4 3 2 1
INCHES

THIS

BECOMES
THIS

PRISMACOLOR.
Kneaded Rubber
Caoutchoc Petri

SO MANY
MARKERS IT'S
ACTUALLY CRAZY I'M
NOT SPONSORED
(RIGHT?! I'M NOT SURE
HOW I DON'T HAVE
A HUGE MARKER
ENDORSEMENT DEAL...)

STAEDTLER
Mars plastic

U.S.A. GENERAL PENCIL CO. © KIMBERLY 525
2H

H1509 MADE IN JAPAN FOR hi-precision DRAFTING
2B

STAEDTLER MARS LUMOGRAPH 100 B
B

MAYBE BECAUSE
YOU ALREADY GIVE
THEM FREE
ADVERTISEMENT?

128

INTERNET

GOOD POINT

I HAVE AN ASTIGMATISM

129

PAGE 105 — MAHATMA GANDHI

PAGE 106-107 — RUPAUL

PAGE 108-109 — PEE-WEE HERMAN

PAGE 110-111 — ANDY WARHOL

PAGE 112 — MARIO

PAGE 114-115 — BARBIE

PAGE 116-117 — SANTA CLAUS

PAGE 120 — BATMAN

PAGE 122-123 — ILANA WEXLER

PAGE 124-125 — ABBI ABRAMS

PAGE 128-129 — TOOLS I USED TO MAKE THIS BOOK

EPILOGUE

This book was never intended to be particularly personal; it was more a concept that interested me and tickled my desire to put pen to paper. And it's not so much that the book even turned out to be about me, but examining other people's lives ended up hugely influencing mine. I feel like I have a new bag all of a sudden and everything I used to carry might not fit anymore.

The bag metaphor feels earned at this point. The process of making this book, and the five months that have gone by while I drew these pages, have been so incredibly significant to me. I moved. I became an expert at to-do lists and Google spreadsheets. I lost some feeling in my right thumb and forefinger— something I'm a bit nervous about. I fainted and smashed my face into my kitchen counter (stitches). I wrote season four of *Broad City*. I learned about managing multiple projects. I learned that I have a lot to learn about managing multiple projects. I fell in love. I surprised myself. I remembered that a tiny idea can come alive if you want it to. I remembered the satisfaction of finishing something big. I remembered that you can find joy in work *and* life, and if you do it right, they fuel each other—like dueling drummers, better and better, one after the other.

Epilogue

I remembered the freedom of a blank piece of paper as you hold a pencil above it . . . the moment before you begin. That moment is powerful. There's not a lot we have control of in our world right now, but making things and creating is ours for the taking. Now that is exciting.

So, this is my book; a silly idea I couldn't stop thinking about. It turned into something I absolutely love, made during a time I'll always remember.

When you can't stop thinking about something . . . well, that's the bull's-eye.

ACKNOWLEDGMENTS

Thank you to everyone at Viking/Penguin, especially my editor, Meg Leder, for her vision and support in making this book happen.

Thank you to my parents who have always been so extremely encouraging of everything I've ever set out to do. Art and creating things were such a constant in my house growing up, and this book can probably be traced back to a sketchbook in our kitchen at 1078 King of Prussia Road. Art supplies were the gift of choice for my brother and me, and my parents nudged that hobby into a habit, which eventually became a passion. Thank you for being my biggest cheerleaders, my consistent advisors and confidants. I'm so very lucky to have you in my corner.

Thank you to Barry and Barb for your endless support and enthusiasm. I appreciate it more than you know.

Thank you to my brother, Brian, for being the person I always have and always will look up to. The sharpest and most innovative designer; the one I strive to impress. Thank you for being my font resource, my breaktime-FaceTime, and for always inspiring me. Thank you to Molly for being my favorite catch-up call

and for living your life in a way that makes me strive to live mine better. Thank you to Stella and Mae for all the late-night conference calls and comped rooms in Atlantic City—you two are wild!

Thank you to Ilana Glazer, my partner in crime. Your support and understanding while I drew this book was immeasurable. Thank you for always making me laugh and telling me over and over that I could finish this and that we'd be okay. You're my favorite person to procrastinate with.

Thank you to Drew "Diz" Hudson, my right-hand man during the creation of this book.

For their support and inspiration I'd like to thank all my friends and family. Special thanks to Carrie Brownstein, Paul W. Downs, Lucia Aniello, Jen Statsky, David Rooklin, Brooke Posch, Amy Poehler, Lilly Burns, Tony Hernandez, and my entire *Broad City* family.

Thank you to my agents, Susie Fox and John Sacks. Thank you to Gregory McKnight, Sasha Raskin, and Shannon Kelly. Thank you to my lawyers, Michael Auerbach and Karl Austin.

Thank *you* for checking it out.

Maya — Imperial Violet

1991 — TULIP

Ilana — Ultramarine Light

Sherlock H — Oatmeal

Peewee — Ash Grey

85K — Carmine Red Light

Santa — Clay Rose

Barbie — Neon Pink

RuPaul — Pink

Leslie E — Mulberry light

FRIDA — TWEEZERS ← Just to fuck w/em.

Obscurities Desires Anger

Regrets Fears Hopes

____ oral baggage dreams

____ s/days Pride Snake

Hillary — Pale Vermillion

SNARE
Pug
Polaroid.
Rolette
$438

er WNM

M T W TH F

LAST 3 SPREAD
SKETCHES

AIRE BATHS
SUNDAY 3RD
11AM

PASSABLE

10 SINGLE
SKETCHES

PONDERING
CHUNKY
WALLETS

SINGLE PAGES

HARRY POTTER DUNEE
JOE BIDEN. SYRUP/WHIPPED CREAM
ANN
LOST + FOUND

MEATY

HBO —
TBS —
FX —

S SU M T

YOU
ARE
WHAT
YOU
CARRY

60

Bowie — Light Aqua

Quotes

Charlie invoices

VERTICAL STRIPES
INK BLUE

have to know where we've been
When you're making history, you ~~keep the~~

King James Bible

Eames — Apple
Joey Trib — violet blue light.
Marty — Muted turquoise
Banksy — Spanish Orange